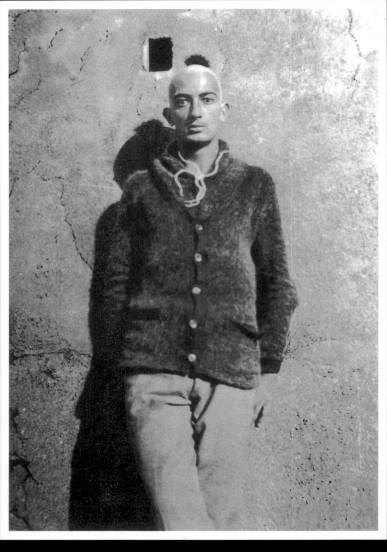

Salvador Dalí in Cadaqués, 1929.
Photograph by Luis Buñuel.
© Fonds Luis Buñuel.

The following abbreviations are used in footnotes for works frequently referred to:

Diary Unpublished diaries of Salvador Dalí entitled 'Les meves impressions i records íntims' preserved in the Archive of the Fundació Gala Salvador Dalí, Figueres.

Secret Life Salvador Dalí. *The Secret Life of Salvador Dalí*, trans. Haakon M. Chevalier (1942), 3rd ed., London, 1968.

Letters to Lorca Rafael Santos Torroella (ed.), 'Salvador Dalí escribe a Federico García Lorca', *Poesia* (Madrid) no.27–28, 1987.

Salvador Dalí: the early years

Pure rose, clean of artifice and rough sketches,
opening for us the slender wings of the smile.
(Pinned butterfly that ponders its flight.)
Rose of balance, with no self-inflicted pains.
Always the rose!

*

Oh Salvador Dalí, of the olive-colored voice!
I speak of what your person and your paintings tell me.
I do not praise your halting adolescent brush,
but I sing the steady aim of your arrows.

I sing your fair struggle of Catalan lights,
your love of what might be made clear.
I sing your astronomical and tender heart,
a never-wounded deck of French cards.

I sing your restless longing for the statue,
your fear of the feelings that await you in the street.
I sing the small sea siren who sings to you,
riding her bicycle of corals and conches.

But above all I sing a common thought
that joins us in the dark and golden hours.
The light that blinds our eyes is not art.
Rather it is love, friendship, crossed swords.

Not the picture you patiently trace,
but the breast of Theresa, she of sleepless skin,
the tight-wound curls of Mathilde the ungrateful,
our friendship, painted bright as a game board.

May fingerprints of blood on gold
streak the heart of eternal Catalunya.
May stars like falconless fists shine on you,
while your painting and your life break into flower.

Don't watch the water clock with its membraned wings
or the hard scythe of the allegory.
Always in the air, dress and undress your brush
before the sea peopled with sailors and with ships.

Rosa pura que limpia de artificios y croquis
y nos abre las alas tenues de la sonrisa.
(Mariposa clavada que medita su vuelo.)
Rosa del equilibrio sin dolores buscados.
¡Siempre la rosa!

*

¡Oh Salvador Dalí de voz aceitunada!
Digo lo que me dicen tu persona y tus cuadros.
No alabo tu imperfecto pincel adolescente,
pero canto la firme dirección de tus flechas.

Canto tu bello esfuerzo de luces catalanas,
tu amor a lo que tiene explicación posible.
Canto tu corazón astronómico y tierno,
de baraja francesa y sin ninguna herida.

Canto el ansia de estatua que persigues sin tregua,
el miedo a la emoción que te aguarda en la calle.
Canto la sirenita de la mar que te canta
montada en bicicleta de corales y conchas.

Pero ante todo canto un común pensamiento
que nos une en las horas oscuras y doradas.
No es el Arte la luz que nos ciega los ojos.
Es primero el amor, la amistad o la esgrima.

Es primero que el cuadro que paciente dibujas
el seno de Teresa, la de cutis insomne,
el apretado bucle de Matilde la ingrata,
nuestra amistad pintada como un juego de oca.

Huellas dactilográficas de sangre sobre el oro,
rayen el corazón de Cataluña eterna.
Estrellas como puños sin halcón te relumbren,
mientras que tu pintura y tu vida florecen.

No mires la clepsidra con alas membranosas,
ni la dura guadaña de las alegorías.
Viste y desnuda siempre tu pincel en el aire
frente a la mar poblada con barcos y marinos.

Translated by William Bryant Logan

Oh Salvador Dalí of the olive-colored voice!
I do not praise your halting adolescent brush
or your pigments that flirt with the pigment of your times,
but I laud your longing for eternity with limits.

Sanitary soul, you live upon new marble.
You run from the dark jungle of improbable forms.
Your fancy reaches only as far as your hands,
and you enjoy the sonnet of the sea in your window.

The world is dull penumbra and disorder
in the foreground where man is found.
But now the stars, concealing landscapes,
reveal the perfect schema of their courses.

The current of time pools and gains order
in the numbered forms of century after century.
And conquered Death takes refuge trembling
in the tight circle of the present instant.

When you take up your palette, a bullet hole in its wing,
you call on the light that brings the olive tree to life.
The broad light of Minerva, builder of scaffolds,
where there is no room for dream or its hazy flower.

You call on the old light that stays on the brow,
not descending to the mouth or the heart of man.
A light that the loving vines of Bacchus
and the chaotic force of curving water fear.

You do well when you post warning flags
along the dark limit that shines in the night.
As a painter, you refuse to have your forms softened
by the shifting cotton of an unexpected cloud.

The fish in the fishbowl and the bird in the cage.
You refuse to invent them in the sea or the air.
You stylize or copy once you have seen
their small, agile bodies with your honest eyes.

You love a matter definite and exact,
where the toadstool cannot pitch its camp.
You love the architecture that builds on the absent
and admit the flag simply as a joke.

The steel compass tells its short, elastic verse.
Unknown islands rise to deny the sphere exists.
The straight line tells of its upward struggle
and the learned crystals sing their geometries.

*

But also the rose of the garden where you live.
Always the rose, always, our north and south!
Calm and ingathered like an eyeless statue,
not knowing the buried struggle it provokes.

¡Oh Salvador Dalí, de voz aceitunada!
No elogio tu imperfecto pincel adolescente
ni tu color que ronda la color de tu tiempo,
pero alabo tus ansias de eterno limitado.

Alma higiénica, vives sobre mármoles nuevos.
Huyes la oscura selva de formas increíbles.
Tu fantasía llega donde llegan tus manos,
y gozas el soneto del mar en tu ventana.

El mundo tiene sordas penumbras y desorden,
en los primeros términos que el humano frecuenta.
Pero ya las estrellas ocultando paisajes,
señalan el esquema perfecto de sus órbitas.

La corriente del tiempo se remansa y ordena
en las formas numéricas de un siglo y otro siglo.
Y la Muerte vencida se refugia temblando
en el círculo estrecho del minuto presente.

Al coger tu paleta, con un tiro en un ala,
pides la luz que anima la copa del olivo.
Ancha luz de Minerva, constructora de andamios,
donde no cabe el sueño ni su flora inexacta.

Pides la luz antigua que se queda en la frente,
sin bajar a la boca ni al corazón del hombre.
Luz que temen las vides entrañables de Baco
y la fuerza sin orden que lleva el agua curva.

Haces bien en poner banderines de aviso,
en el límite oscuro que relumbra de noche.
Como pintor no quieres que te ablande la forma
el algodón cambiante de una nube imprevista.

El pez en la pecera y el pájaro en la jaula.
No quieres inventarlos en el mar o en el viento.
Estilizas o copias después de haber mirado,
con honestas pupilas sus cuerpecillos ágiles.

Amas una materia definida y exacta
donde el hongo no pueda poner su campamento.
Amas la arquitectura que construye en lo ausente
y admites la bandera como una simple broma.

Dice el compás de acero su corto verso elástico.
Desconocidas islas desmiente ya la esfera.
Dice la línea recta su vertical esfuerzo
y los sabios cristales cantan sus geometrías.

*

Pero también la rosa del jardín donde vives.
¡Siempre la rosa, siempre, norte y sur de nosotros!
Tranquila y concentrada como una estatua ciega,
ignorante de esfuerzos soterrados que causa.

Ode to Salvador Dalí

Federico García Lorca

A rose in the high garden you desire.
A wheel in the pure syntax of steel.
The mountain stripped bare of Impressionist fog.
The grays watching over the last balustrades.

The modern painters in their white ateliers
clip the square root's sterilized flower.
In the waters of the Seine a marble iceberg
chills the windows and scatters the ivy.

Man treads firmly on the cobbled streets.
Crystals hide from the magic of reflections.
The Government has closed the perfume stores.
The machine perpetuates its binary beat.

An absence of forests and screens and brows
roams across the roofs of the old houses.
The air polishes its prism on the sea
and the horizon rises like a great aqueduct.

Soldiers who know no wine and no penumbra
behead the sirens on the seas of lead.
Night, black statue of prudence, holds
the moon's round mirror in her hand.

A desire for forms and limits overwhelms us.
Here comes the man who sees with a yellow ruler.
Venus is a white still life
and the butterfly collectors run away.

*

Cadaqués, at the fulcrum of water and hill,
lifts flights of stairs and hides seashells.
Wooden flutes pacify the air.
An ancient woodland god gives the children fruit.

Her fishermen sleep dreamless on the sand.
On the high seas a rose is their compass.
The horizon, virgin of wounded handkerchiefs,
links the great crystals of fish and moon.

A hard diadem of white brigantines
encircles bitter foreheads and hair of sand.
The sirens convince, but they don't beguile,
and they come if we show a glass of fresh water.

*

Oda a Salvador Dalí

Una rosa en el alto jardín que tú deseas.
Una rueda en la pura sintaxis del acero.
Desnuda la montaña de niebla impresionista.
Los grises oteando sus balaustradas últimas.

Los pintores modernos en sus blancos estudios,
cortan la flor aséptica de la raíz cuadrada.
En las aguas del Sena un *ice-berg* de mármol
enfría las ventanas y disipa las yedras.

El hombre pisa fuerte las calles enlosadas.
Los cristales esquivan la magia del reflejo.
El Gobierno ha cerrado las tiendas de perfume.
La máquina eterniza sus compases binarios.

Una ausencia de bosques, biombos y entrecejos
yerra por los tejados de las casas antiguas.
El aire pulimenta su prisma sobre el mar
y el horizonte sube como un gran acueducto.

Marineros que ignoran el vino y la penumbra,
decapitan sirenas en los mares de plomo.
La Noche, negra estatua de la prudencia, tiene
el espejo redondo de la luna en su mano.

Un deseo de formas y límites nos gana.
Viene el hombre que mira con el metro amarillo.
Venus es una blanca naturaleza muerta
y los coleccionistas de mariposas huyen.

*

Cadaqués, en el fiel del agua y la colina,
eleva escalinatas y oculta caracolas.
Las flautas de madera pacifican el aire.
Un viejo dios silvestre da frutas a los niños.

Sus pescadores duermen, sin ensueño, en la arena.
En alta mar les sirve de brújula una rosa.
El horizonte virgen de pañuelos heridos,
junta los grandes vidrios del pez y de la luna.

Una dura corona de blancos bergantines
ciñe frentes amargas y cabellos de arena.
Las sirenas convencen, pero no sugestionan,
y salen si mostramos un vaso de agua dulce.

*

Petersburg, Florida. To them we express all our admiration and thanks.

We would also like to thank Henry Meyric Hughes, Director of Exhibitions at the South Bank Centre, for the full support given to this project from its inception and for the selection and organization undertaken by Dawn Ades and Andrew Dempsey, who have worked with characteristic professionalism, as have William S. Lieberman, Jacques and Natasha Gelman Chairman of Twentieth Century Art at The Metropolitan Museum of Art in New York, and his colleagues, who have enthusiastically helped with the exhibition.

Our sincere thanks also to the Banco Bilbao Vizcaya, which has for many years supported important cultural events, for this new example of their generous sponsorship in London and Madrid. Finally, our gratitude is also extended to The Andrew W. Mellon Foundation for its support of the exhibition in New York.

Ana Beristain
Curator, Museo Nacional Centro de Arte Reina Sofía
and Trustee of the Fundació Gala-Salvador Dalí

The organizers of the exhibition would like to express their gratitude to the following: Agnès de la Beaumelle, Ian Christie, Yasha David, Nicolas Descharnes, William Peter Kosmas and John Tancock; to the following museum restorers: Georgina Berini, Paloma Calopa, José Mª Guillaumet, Mª del Mar Pérez, Antonio Rocha, Rosa Rubio, Pilar Sedano, Ubaldo Sedano, Eulalio Pozo, Carmen Fernández, Gabriel Fuertes, Gloria Morales, Sagrario Moreno, Carmen Rodríguez, Javier Tacón; and to Fernando Delgado, José Antonio Díaz Tuesta, Paloma Esteban Leal, Charo Sanz Rueda, Carmen Sánchez, Eduardo Berzosa Alonso-Martinez.

Curator's preface

'Salvador Dalí Domènech Felipe Jacinto, Marquess of Dalí and Pubol, for the glory of Spain and in the service of our Nation, apolitical and anarchic, bound forever to the four stripes of immortal Catalunya, under the sky's dome over which is raised the divine crown of our King. Dalí is the greatest singularity of Spain.'

With these expressive and significant words our artist ended the introduction to his exhibition '400 Works of Salvador Dalí' which was shown in Madrid and Barcelona in 1983. In the present exhibition it is the early period of this 'greatest singularity' which we are analysing, searching amongst those crucial moments for ways to help our understanding of his later work.

Although some works of these years have been shown in a number of important exhibitions, it has only been possible since Dalí's death in January 1989 to present a coherent and considered selection. This is due in large part to the special regard in which the artist held these works, keeping them zealously away from the sight of dealers and collectors. Some he hung himself in his great surrealist object, the Teatro-Museo Dalí in Figueres which was opened in 1974, others form part of his generous bequest to the Spanish nation which has been placed under the care of the Museo Nacional Centro de Arte Reina Sofía in Madrid and the Fundació Gala-Salvador Dalí in Figueres.

The Dalí Bequest consists in part of buildings of national significance, of which the house at Port Lligat and the castle at Pubol stand out as of historical and cultural importance. Port Lligat was destined, from his early years when he was obliged to leave his father's house, to be his permanent home and a source of inspiration to his work; the castle at Pubol, acquired in the years of his maturity, was to be the place where he would pass much of his time during the last years of a long life, and is today the resting place of his inseparable muse, Gala.

The works of art in the Bequest include almost two hundred paintings and more than two thousand original works on paper from every period of Dalí's life. They have been carefully catalogued and restored in recent years. In addition, there is a varied and interesting collection of unpublished writings by the artist himself and of other documentation, which is also being put into order and studied.

Our hope in presenting this exhibition, in which we are showing many works from the Bequest which have remained unpublished until now, together with others of no less importance which have been generously lent by museums and private collectors – accompanied by a catalogue in which a number of specialists analyse the works from Dalí's early years until his entry, already by the hand of Gala, into the world of the Paris Surrealists – is that it will help us to understand and appreciate this 'greatest singularity' of Salvador Dalí.

This exhibition has been made possible in great measure due to the interest and generosity of the Fundació Gala-Salvador Dalí which is the custodian, in the inimitable Teatro-Museo of Figueres, of the works which the artist presented during his lifetime, together with an important part of the bequest made after his death (the latter being shared with the Museo Nacional Centro de Arte Reina Sofía). The Foundation has made a most generous gesture on this occasion of lending some of the most admired works from its permanent displays.

The close friends and magnificent collectors of Salvador Dalí, Eleanor and Reynolds Morse, have shown quite exceptional generosity in lending works for which there are no substitutes from their Salvador Dalí Museum in St.

Foreword and acknowledgments

This is a portrait of the artist as a young man; an unusual exhibition in that it leaves its subject at the age of twenty-seven on the threshold of a brilliant career in the art world, and indeed in the social world, of Europe and America. Unusual also in that its close focus is more like that of a biography than an art exhibition: it tells a story as well as displaying some remarkable works of art, and indeed some masterpieces. This is a young man's story, a story of family and friendships, in particular the friendship between three of the most remarkable Spaniards of their generation: the painter Salvador Dalí, who is the subject of our exhibition, the poet Federico García Lorca and the film-maker Luis Buñuel. This is an important story, as our century would be much the poorer without these three extraordinary men.

We have combined our resources to make this exhibition, but we could not have succeeded without the help of our lenders, amongst whom we would like to make special mention, for agreeing such exceptionally generous loans, of Mr. and Mrs. Reynolds Morse, founders of the Salvador Dalí Museum in St. Petersburg, Florida, and to acknowledge at the same time the help given throughout by the Museum's Director, Marshall Rousseau, and Curator, Joan Kropf. We are also especially grateful to the Fundación Federico García Lorca in Madrid, and to its Director Manuel Fernández Montesinos García. The Foundation has lent important and fascinating documents as well as a number of paintings and drawings. We are no less grateful, of course, to our other lenders, both public and private, who are listed in this catalogue.

We are also greatly indebted to the Banco Bilbao Vizcaya for the support they have given to this exhibition in Europe and we should like to thank the Bank's President, Emilio Ybarra y Churruca, as well as the Director General for Social and Cultural Activities, Antonio López, and his colleague Concepción Badiola Vallejo. We are also most grateful to The Andrew W. Mellon Foundation for its generous support of the exhibition in New York.

Our thanks also go to the curators of the exhibition, Dawn Ades and Ana Beristain; to Andrew Dempsey, coordinator of the project; to Michael Raeburn, the editor of this catalogue; and to its designer, Dennis Bailey; as well as to our authors, Rafael Santos Torroella, Ian Gibson, Fèlix Fanés and Montserrat Aguer of the Centre d'Estudis Dalinians, Agustín Sánchez Vidal and Dawn Ades, who have all contributed illuminating chapters to our biography. We are grateful also to Robert Descharnes for advice and help throughout the realization of the project, especially for help with tracing paintings.

Lastly, but importantly, we should like to express our appreciation of the efforts of our colleagues who have undertaken the realization of the exhibition in London where it is part of the Spanish Arts Festival, in New York, Madrid and Barcelona.

Henry Meyric Hughes
Director of Exhibitions, South Bank Centre, London

María de Corral
Director, Museo Nacional Centro de Arte Reina Sofía, Madrid

Philippe de Montebello
Director, The Metropolitan Museum of Art, New York

Antoni Pitxot
Director, Teatro-Museo Dalí, Figueres

Contents

Published on the occasion of the exhibition
Salvador Dalí: The Early Years at the Hayward Gallery, London
3 March – 30 May 1994 and at The Metropolitan Museum of Art,
New York, 28 June – 18 September 1994.

Translations of essays by Alison Turnbull and Nick Caistor; additional
translations by Ian Gibson, Michael Raeburn, Claire Mulderrig

This hardback edition first published in Great Britain in 1994
by Thames and Hudson Ltd, London

First published in the United States of America in 1994 by
Thames and Hudson Inc., 500 Fifth Avenue, New York, NY 10110

British Library Cataloguing-in-Publication Data

A catalogue record for this book is available from the
British Library and also from the Library of Congress

ISBN 0-500-23689-5

Catalogue edited by Michael Raeburn
Designed by Bailey and Kenny

Printed and bound in Great Britain

Salvador Dalí: the early years

Ian Gibson
Rafael Santos Torroella
Fèlix Fanés
Dawn Ades
Agustín Sánchez Vidal

Edited by Michael Raeburn

THAMES AND HUDSON

Illustrated biography
Montserrat Aguer and Fèlix Fanés

1904

Salvador Dalí Domènech is born on 11 May, second son of the notary public Salvador Dalí Cusí, aged 41 and his wife Felipa Domènech Ferrés, aged 30. He is given the same first name, Salvador, as his brother, who had been born on 12 October 1901 and had died on 1 August 1903. According to the painter, the premature death of his brother was to cast a permanent shadow over his life, as he explains in his *Secret Life*:

> My brother and I resembled each other like two drops of water, but we had different reflections. Like myself he had the unmistakable facial morphology of a genius. He gave signs of alarming precocity, but his glance was veiled by the melancholy characterizing insurmountable intelligence. I, on the other hand, was much less intelligent, but I reflected everything. [...] In other words, I was viable. My brother was probably a first version of myself, but conceived too much in the absolute. [1]

1908

In January Salvador's sister, Anna Maria, is born. Later she writes about their native town:

> Figueres [...] was an open, bright, liberal, extrovert, stately town, with an intellectual restlessness which lent it an air of nobility, despite the fact that every Thursday the great hubbub of the weekly market turned it into a farming town. The streets and squares became open-air shops where fowls, grain, vegetables and cattle

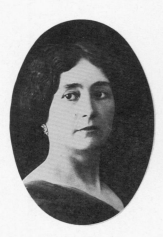

Felipa Domènech Ferrés
(no.155).

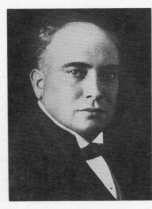

Salvador Dalí Cusí (no.154).

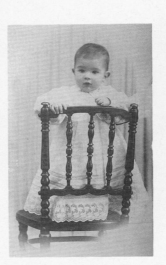

Salvador Dalí Domènech
(no.156).

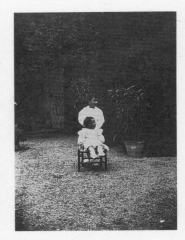

Anna Maria and Salvador Dalí.
Private collection.

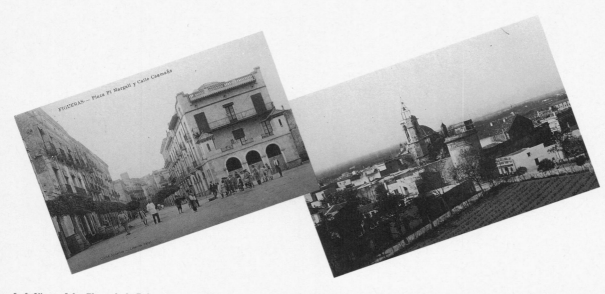

Left: View of the Plaça de la Palmera, Figueres; the house the Dalí family moved to in 1912 is the third on the right. Josep M. Joan collection, Figueres.

Right: View of the church and town of Figueres. Josep M. Joan collection, Figueres.

were traded. The whole scene was dominated by the colour and movement of the black and red Catalan caps, as farmers from all over the region came to the market, creating all conceivable bustle and noise. This bustle and noise contrasted greatly with the atmosphere on a Sunday, when the elegantly dressed people of Figueres would gather together beneath the shade of the plane trees on the main square to listen to the music played by the band of the Sant Quintí regiment. They performed waltzes by Strauss and Franz Lehár, while the officers, sporting their ribbons and sashes of sky-blue silk and their chests covered with gold medals, paid compliments to the young ladies. It was at moments like this that Figueres looked like a small town in an operetta.[2]

Because his father is a freethinker, Salvador, instead of being enrolled in a religious school, as would have been normal for people of their social standing, is sent to the municipal kindergarten (Escuela Pública de Parvulos de Figueres), where his teacher is Esteban Trayter.

1910

After two years father descides to enroll him in the Colegio Hispano-Francés de la Inmaculada Concepción, where he learns French, his future adopted language. During the six years he spends there he is not an outstanding pupil and makes little progress.

It is probably during this period that he begins to read art books, notably the Gowans Art Books series (no. 144).

1916

Salvador Dalí and Pepito Pichot at the first air show in Figueres, 1912 (no.157).

During the summer his parents send him on holiday to the country home of the Pichot family, 'El Molí de la Torre' just outside Figueres. The Pichots are an artistic family; Ramon is a painter, Ricard a cellist (a pupil of Pau Casals), Luis a violinist (a pupil of Jacques Thibaut) and María (married to Joan Gay) an opera singer, a famous Carmen who sings in all the great opera houses of Europe and America. Another daughter, Mercedes, is married to the poet and playwright Eduardo Marquina. José (Pepito), the eldest, is very friendly with Salvador Dalí Cusí and will later become an important mentor to the young artist.

It is through Ramon's pictures that Dalí discovers French Impressionism. Ramon Pichot (Barcelona, 1871–Paris, 1925) also seems to have been Dalí's first role model as a professional painter. A friend of Ramon Casas and Santiago Rusiñol, Ramon had been associated with the symbolist and *modernista* movements in Catalunya and

now divides his time between Cadaqués and Paris. There he is a close friend of Picasso, whom he had first met in Barcelona and had invited to spend the summer of 1910 in their house in Cadaqués. Apollinaire had written of Ramon Pichot:

> [He] is a member of that brilliant group of Spanish painters in Paris who are continuing the tradition of Goya or, better still, Velázquez ... It is particularly in his marvellous coloured etchings that Ramón Pichot proves himself a member of the Spanish school.[5]

It is perfectly possible that without being aware of it, Salvador Dalí, then a six-year-old boy, would have been playing not far from Picasso, by then twenty-nine years old, in the garden of the Pichot family home above Sa Conca in Cadaqués.

After his poor showing at primary school, in the autumn Salvador begins his secondary education at the Figueres Instituto and the Marist Brothers' College. In the mornings he goes to the Instituto for the standard curriculum and in the afternoons he supplements this with the more specialized teaching of the Marists.

He also attends classes given by Juan Núñez at the Municipal Drawing School. Juan Núñez (Estepona, Málaga, 1877 – Barcelona, 1963) was a draughtsman, painter and engraver with an academic training. He studied at the Escuela Especial de Bellas Artes in Madrid and then at the Spanish Academy in Rome, a city in which he lived for some years. On his return to Spain in 1905 he began to teach and in 1906 moved to Figueres, where he exerted considerable influence on his students in his dual role as Professor of Drawing at the Instituto and as a teacher at the Municipal Drawing School.

During this and the following year Dalí writes and illustrates stories for his sister when she is ill (no.2).

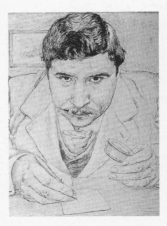

Juan Nuñez. *Self-Portrait*, 1903, engraving. Private collection.

1917

An exhibition of Dalí's charcoal drawings is organized for him by his father at their home.

1918

Dalí contributes a drawing to the popular Catalan magazine *Patufet*.

Dalí. Drawings for the artist's sister, 1917, ink on paper, 32.5 × 24.5 (no.2).

Ramon Pichot. *Seascape*, oil on canvas, 41 × 61. Private collection.

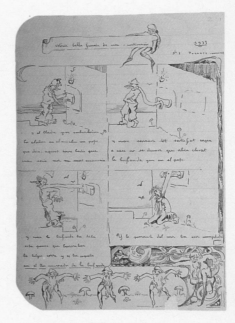

Dalí. Illustration published in *Patufet*, 1918.

January: Dalí participates in the group exhibition of the Sociedad de Conciertos in Figueres. Two of his paintings are bought by Joaquim Cusí, a friend of the painter's father. They are the first works he has sold. In the local newspaper *Empordà Federal*, 11 January, Dalí's work is praised in the following terms:

> Dalí Domènech, a man who can feel the light, whose vitality can be sensed in this graceful representation of a fisherman, who at the age of sixteen years shows great daring in the luscious, warm brushstrokes of *The Drinker*, who has such a refined decorative sense, as demonstrated in his charcoal sketches – especially that of *The Fortification* – is already one of those artists who will cause a great sensation, one of those who will produce great pictures even when the attempt is made to make him produce things as unartistic as ledger-entries… for example. We welcome this new artist and express our belief that at some point in the future our humble words will prove to be prophetic: Salvador Dalí Domènech will be a great painter.

Dalí collaborates on the magazine *Studium*, which is published from January to June of 1919 by a group of students and friends at the Figueres Instituto. He contributes drawings, a poem and a series of articles on art, 'The Great Masters of Painting'. The editor is Joan Xirau and the other contributors are Ramon Reig, Jaume Miravitlles and Joan Turró. He writes in a scholarly and academic tone about the artists he admires: Goya (January), El Greco (February), Dürer (March), Leonardo da Vinci (April), Michelangelo (May) and Velázquez (June). Of the latter he writes:

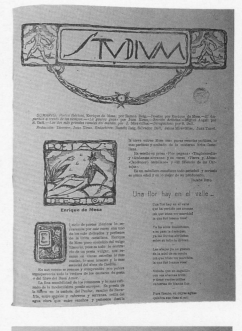

> Vitality and energy predominate in Velázquez's portraits; his harsh, crudely etched outlines create a strong initial impression of roughness, which is later dissipated when we become aware of the deeply serene expressions on the faces of his sitters – almost always full of intelligence and strength.
>
> All the figures in his portraits [...], with their strength and vitality portray a Spain that Velázquez copied – or rather 'created' – from real life.
>
> This painter also possessed an outstanding technique, and the impression of simplicity in genre paintings such as 'Las Meninas' and 'Las Hilanderas' is the result of unsurpassed technical brilliance. The distribution and placing of colours are in some instances not unlike those of an 'impressionist' painter.

He also collaborates with other friends in Figueres on the humorous publication *El Sanyó Pancraci*, painting an imaginary portrait of its hero.

Pages from *Studium* (no.5 and no. 4), text and illustrations by Dalí, 1 May, 1 April 1919. Private collection, Cadaqués (no.126).

During this period Dalí thinks of himself as an impressionist painter, as is shown by a letter written to his uncle Anselm Domènech:

> Every day I realize more and more how difficult art is ... but also every day I rejoice and like it. I continue to admire the great French Impressionists, Manet, Degas, Renoir. I would like them to become the strongest guiding forces in my life.[4]

He begins to write a novel, *Tardes d'estiu [Summer evenings]* (no.129), which remained unpublished. At the very beginning of the narrative Dalí introduces the main character and gives us the tone of the story:

> Lluís was an orphan boy, his parents having died from a hereditary form of consumption. His doctors had recommended that he spend some time in a mountain village and he had chosen Horta Fresca because it was so beautiful and picturesque; for Lluís had a strongly artistic temperament, having dedicated his life to painting; he was one of those romantic poets who live in the heart of Paris, one of those who fall in love at the age of twelve and who, tired of being misunderstood, leap into the Seine on a moonlit night.
> Later he began to paint. It was a wonderful theme for a canvas: in the foreground the patio of a neighbouring house, a whitewashed patio which, when the sun shone upon it, became a most delicate riot of colour. In the very middle of the patio there grew a proud cherry tree laden with cherries, which further gladdened that collection of delicate colours. In the distance was the whole plain with its fruit and vegetable plots and its fields glowing with light and warmth, and there, beyond all else, on the horizon itself ... the vibrant blue stripe of the sea.
> He began to paint with pleasure, with feverishness. The wildness of the light and colour rendered him morally inebriated, and he painted with intense longing, with desire ... like a madman.
> His passionate temperament meant that he painted more with his heart than with his mind ... and, blinded by the overwhelming beauty of nature, he spent hours and hours searching for light, now pursuing one colour, now another. Lluís gave to it his whole spirit, his whole soul.

Dalí's father insists that if he wants to become a painter, he must go to Madrid to study at the Escuela de Bellas Artes, with the aim of obtaining a teaching qualification. Dalí accepts. He records it in his diary as follows:

> The supreme and perhaps most important decision of my life, since it indicates the direction that I have to follow, is the following (which has been approved by my family): I shall quickly finish my *bachillerato*, if necessary doing the remaining two years in just one. Then I'll go to Madrid to the Academia de Bellas Artes ... There I intend to spend three years working like mad, anyway the Academia is a fine place. Then by sacrificing myself and submitting to truth I will win the prize to study for four years in Rome; and coming back from Rome I'll be a genius, and the world will admire me. Perhaps I'll be despised and misunderstood, but I'll be a genius, a great genius, I am sure of it.[5]

While Dalí studies and writes during the academic year, in the summer he devotes himself to painting. As his father came from Cadaqués – and because of his friendship with the Pichots – the family spend their summer holidays in this little fishing village. Their house is described by Dalí in his diary:

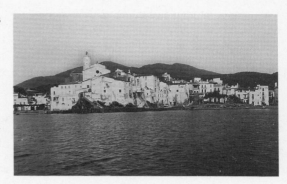

General view of Cadaqués. Josep M. Joan collection, Figueres.

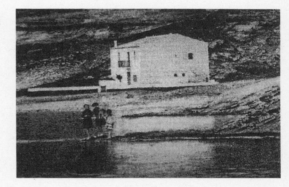

The Dalís' house at Es Llaner, Cadaqués. Private collection.

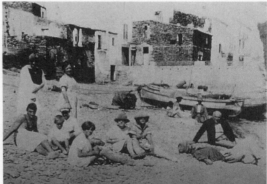

Dalí family on the Llaner beach. Private collection (no.158).

On a beach far from the village, right by the sea, there is a white house. The windows and balconies are painted green. The beams in the dining-room are blue like the sea ... There is a great tranquillity in this place. When the sky grows pale in the evening taking the colour of mother-of-pearl, when the water is still and the first stars appear a great tranquillity reigns. The only sounds are the song of the cricket from the brambles in the gully and the rhythmic noise of oars through the warm air of the broad summer twilight. This white house, which stands in a secluded spot, is our house in Cadaqués.

During the school year Salvador Dalí always looks forward to the time they spend in Cadaqués, where he can devote himself completely to his artistic activity. He writes in his diary:

These past days I have thought of nothing but Cadaqués. Every day I have looked longingly at the calendar, counting the days until we can get there ... I am already getting all my things ready, my painting equipment, and I look with sparkling eyes at the colours I keep in the cupboard, those luminous tubes from Can Teixidor, in which I see a whole world of hopes ...

As there is not enough room for Dalí to paint in the house in Cadaqués, the Pichot family lend him a space that Ramon had used as a studio. Dalí describes it in his diary:

There was no room in our house for my studio. I found one in the village not far from the house. It was a white room, whitewashed in the upper part, in a poor fishermen's house. Ramon Pichot used to paint in this studio. Several little figures done by him can be seen on the walls, some of them quite interesting, and spots of paint spattered on the wall.

There was a baroque altar where I put a pot filled with rosemary and thistles. I arranged my books in a worm-eaten cupboard. Some Baroja, some Rubén Darío, some Eza de Queiroz and even a book by Kant which I hadn't opened all summer. I also took my whole collection of Gowans art books and some other books and reproductions. On top of the table I put the jar with my brushes, a box of paints and a sheet of paper, and an inkwell and pencils, and a hammer to straighten frames and stretchers, rolls of Ingres paper and canvas, and the large easel in the middle of the room and the small one hanging from a nail. Always, afterwards, I rubbed my hands with satisfaction when I saw, with emotion, this studio which, almost without realizing, I had begun to love.

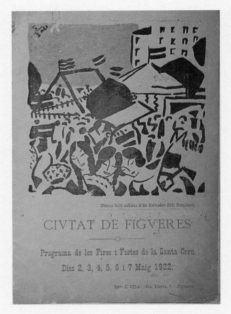

Catalogue for *Fires i Festes de la Santa Creu* with cover designed by Dalí, 1922. Josep Fajol collection, Figueres (no.128).

Dalí's records from the Instituto de Figueres, 1916–22.

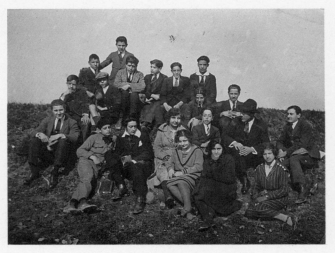

Salvador Dalí and fellow pupils at the Instituto de Figueres, c.1919 (no.159).

1921

6 February: Dalí's mother dies. His father marries Catalina Domènech Ferrés, his first wife's sister, not long afterwards.

May: Dalí designs the posters for the annual festival of Santa Creu de Figueres. He also designs the printed programme for the festival the following year.

1922

January: Dalí exhibits eight works in the Catalan Students' Association collective show at the Galeries Dalmau in Barcelona: *Smiling Venus* (see p.131), *Olive Trees* (see p.133), *Cadaqués*, *Déjeuner sur l'herbe* (see p.90), *Fiesta at the Hermitage* (no.22), *Market*, *Twilight* and *Salome* (possibly no.23); a few are sold. The exhibition is favourably reviewed in the press. The notice in *La Tribuna* (Barcelona) on 27 January reads:

> The 'Associació Catalana d'Estudiants' has organized an exhibition of student work, currently showing at Galeries Dalmau. 134 works are on exhibition, and although in the majority of these technical inexperience is clearly evident, there are some that reveal qualities which demand to be singled out. Among these the paintings of Salvador Dalí deserve special praise. This young artist has already been noticed in these pages as an outstandingly talented new Catalan painter. Here in the Empordà we have been watching the development of this precocious artist, who finds his subject-matter in the natural beauty of the landscape surrounding Cadaqués and Cape Creus. His truly personal artistic vision is abundantly clear in the manner in which he has treated these luminous inlets, finding just the right colour for the time of day and allowing it to impregnate the canvas with sensitivity. He exhibits [...] *Twilight* [...], a lyrical moment of landscape painting in which veiled tones convey the twilight hour. This painting and *Market* are the finest we have seen so far. *Market* richly deserves the Barcelona University's Rector's Prize. The young Dalí is following a path which is sure to lead him to great success.

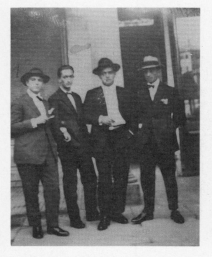

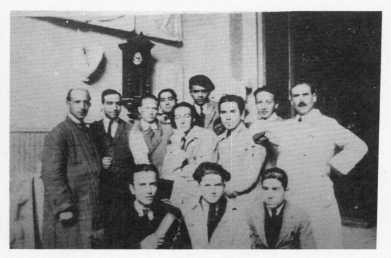

Dalí (second from left) with friends at the Residencia: the poet José Maria Hinojosa, Luis Buñuel and Federico García Lorca. Fundación Federico García Lorca, Madrid.

Salvador Dalí and fellow students at the Special School of Painting, Sculpture and Engraving, Madrid, 1922–3 (no.160).

Dalí finishes his schooling with good marks, as can be seen from his academic report from the Instituto Técnico in Figueres.

He applies for admission to the Special School of Painting, Sculpture and Engraving (Academia de San Fernando) in Madrid. On passing the entrance examination he moves to the capital and takes up a place at the Residencia de Estudiantes, one of the most advanced centres of culture in Spain. Modelled loosely on an Oxford or Cambridge college, the Residencia offers no tuition or courses – although special lectures are arranged across a broad spectrum of subjects – but aims to forge the students lodging there into an elite intellectual community. Dalí owes his place there to Eduardo Marquina, the husband of Mercedes Pichot, who recommends him to Alberto Jiménez Fraud, the Residencia's director. There he becomes friendly with a group of young fellow-residents who were later also to develop distinguished intellectual and artistic personalities: Luis Buñuel, Federico García Lorca, Pedro Garfias, Eugenio Montes and José (Pepín) Bello among others. He is a constant visitor to the Museo del Prado and attends his classes at the art school, although he is soon to become disillusioned with them.

It is probably at this time that Dalí first becomes aware of cubist painting through a futurist catalogue that Pepito Pichot brings him from Paris, as well as through the magazine *Esprit Nouveau*, which was almost certainly obtained for him by his Uncle Anselm Domènech, proprietor of an important bookshop in Barcelona.

He begins to produce cubist paintings.

Below: Dalí's copy of the book by Boccioni, *Pittura scultura futuriste (Dinamismo plastico)*, Milan, 1914, with his own drawings in the margins, c.1922. Private collection (no.127).

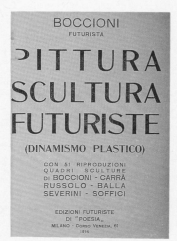

1923

22 October: He is suspended by the Disciplinary Council of the art school for a year; the reasons are set out in a letter from the Secretary of the school:

> It is brought to your attention that at the special meeting of the Disciplinary Council convened on the above date because of the disturbance in the courtyard of the school on the afternoon of the 17th of this month and of the insults directed at the Professors of the same, and in light of the statements made at said Council that you are among those whose conduct demonstrated the most flagrant breach of discipline, the Council has decided, according to article 2, section 10 of the Disciplinary Regulations for academic conduct, to impose the punishment of temporary expulsion from the course for one year with the loss of the right to sit examinations in any subjects in which you are now enrolled.

The disturbance that the letter refers to came about because the eminent painter Daniel Vázquez Díaz failed to be appointed as Professor of Open-Air Painting, to the anger of the many students who supported his candidature. Dalí is considered to be the ringleader of the protest organized by the students.

1924

Unable to continue his classes at the art school, Dalí spends part of the 1923–4 session attending classes at the Academia Libre, founded in Madrid by Julio Moisés, where he makes drawings from the nude model. His fellow students include Maruja Mallo, Benjamín Palencia, Francisco Bores and José Moreno Villa.

24 May: The young artist is imprisoned in Figueres as a reprisal against his father for the (liberal) political activities in which he had been involved in connection with events during local elections against the Dictatorship. (Faced with the traditional parties' growing inability to form a strong government, capable of dealing with the increasingly radical action of the workers and with the general increase in sympathy for republican and nationalist causes, General Miguel Primo de Rivera acted with Alfonso XIII's approval to become chief of state with dictatorial powers from 13 September 1923 to 28 January 1930, the period known as the Dictatorship of Primo de Rivera). After nine days Dalí is transferred to the jail in Girona, where he spends a month before finally being released on grounds of insufficient charges against him.

Autumn: Dalí returns to the Academia de San Fernando.

He illustrates *Les Bruixes de Llers [The Witches of Llers]* by Carles Fages de Climent.

Letter addressed to Dalí notifying him of his temporary expulsion from the Special School of Painting, Sculpture and Engraving, 22 October 1923.

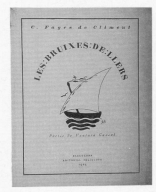

Title page by Dalí for *Les Bruixes de Llers* by Carles Fages de Climent, 1924 (no.146).

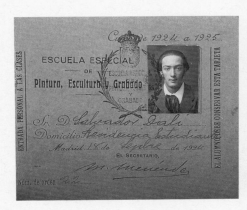

Dalí's student card for the Special School of Painting, Sculpture and Engraving, Madrid, 1924–5 (no.145).

Dalí's enrolment card for art history lectures.

Dalí with Federico García Lorca in Cadaqués, March 1925. Fundación Federico García Lorca, Madrid.

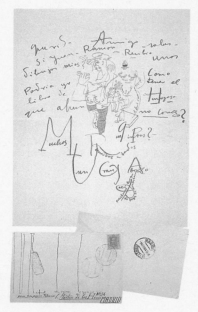

Letter from Dalí to Benjamín Palencia, 30 August 1925, asking if Juan Ramón Jiménez has received his drawings; with drawings related to Venus and sailor compositions (see nos.57–62). Private collection.

1925

At Easter he goes to Cadaqués with Federico García Lorca, and their correspondence begins soon afterwards. What is believed to be Dalí's first letter to García Lorca reads:

> Distinguished friend:
>
> The drawing of the white mantilla is undoubtedly the finest thing I have seen of yours. I was delighted by your letter with all its photographs and all its moods that reminded me of our good times together.
>
> My sister loved your letter and will soon be replying. I've got a marvellous phonograph here and a selection of 'blues' NEVER DREAMT OF ... But I'll end here because I'm afraid both literally and [illegible]."[6]

This correspondence, from which, with a few exceptions, only the letters from Dalí to Lorca survive, gives a sense of the great friendship that linked poet and painter, as well as of the strong intellectual bond that they were to maintain for several years, each exerting a powerful influence upon the other. Signs of this influence can be seen in the portraits and other drawings they exchanged.

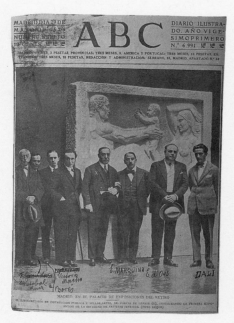

Dalí (right) with artists and writers (Cristóbal Ruiz, Francisco Bores, Victorio Macho, García de Leániz, Eduardo Marquina, Eugeni d'Ors) at the Salón de la Sociedad de Artistas Ibéricos; photograph on cover of *ABC* (Madrid), 29 May 1925.

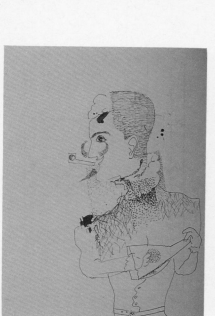

Dalí. Portrait of Federico García Lorca, 1926–7. Ink on paper, 22.2 × 16 (no.86).

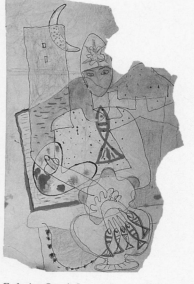

Federico García Lorca. *Portrait of Salvador Dalí*, 1927. Mixed media on paper, 29 × 18.7 (no.138).

May: Dalí takes part in the first Salón de la Sociedad de Artistas Ibéricos in Madrid; he shows some ten paintings, including *Portrait of Luis Buñuel* (no.48), *Female Nude*, *Bather* (see p.134), *Still Life* (see p.134), and *Syphon and Bottle of Rum* (no.50). Rafael Barradas, Norach Borges, Pancho Cossío, José Moreno Villa, Ramon Pichot, José Gutiérrez Solana, José María Ucelay, Aurelio Arteta, Alberto Sánchez, Benjamín Palencia and Ángel Ferrant also take part in this important exhibition.

14–27 November: Dalí has his first one-man exhibition at the Galeries Dalmau in Barcelona. He shows fifteen paintings: *Seated Girl*, *Seated Girl Seen from the Back* (no.66), *Figure at a Window* (see p.83), *Portrait of Ramoneta Montsalvatje* (no.56), *Portrait of My Father* (no.65), *Empordà Landscape with Figures* (no.46), *Cadaqués Landscape* (1917), two entitled *Portrait of My Sister* (including no.67), *Figure in Profile*, *Still Life*, *Figure on a Panel*, *Portrait of Maria Carbona* (no.63), *Venus and Sailor (Homage to Salvat-Papasseit)* (no.61), *Pierrot and Guitar* (i.e., no.53); and five drawings: *Nude on the Beach*, *Portraits* (another version of no.64), *Nudes* (1925), *Portrait of Puig Pujades* (1924) and *Landscape* (1925). Rafael Benet writes about the exhibition in *La Veu de Catalunya* on 27 November:

> Dalí is having his first one-man show in Barcelona at the Galeries Dalmau, and is having a great success with the intellectuals of the Ateneu – with the literary crowd. But the work of this enterprising boy of twenty-one has failed to convince the painters. [...]
>
> To suit his temperament, one must assume, Dalí has investigated avant-garde theories in order to find the crutches on which he can support his own sensibility, which is attuned to novelty and perfection, but our artist has acquainted himself with everything that is going on around him in a way that is too cerebral: too philosophical and not sufficiently artistic. The very soundness of his art, totally verticalist and constrained, gives an initial sensation of a complete lack of lyricism. But if one looks with greater attention at the whole work, even at its most constrained, one can see that the lyrical quality of his paintings has a much more 'balanced' grace that one could ever have imagined. For this reason Dalí seems to us much closer to the Italian realists of Valori Plastici than to the French cubists, with the exception of Ozenfant. Because of this kinship with the Italians the young man from Empordà seems to us more of a decorator than a painter. His least abstract work is indebted to the neoclassical style of Casorati or even the 'academicism' of Ubaldo Oppi.

The painter himself writes about the exhibition in a letter to Federico García Lorca:

> Dear Federico
> The exhibition has been a complete success, both critically and in terms of sales. I have been given a banquet, etc, etc.
> I enclose the *harshest* criticism, the others aren't of any interest because they are so unconditionally enthusiastic.
> What are you up to? Drawing? Don't you fail to write to me – you, the only interesting man I've ever known.
> I assume you got a letter from me and *Barradas* ... You can't imagine how intense life was during the exhibition.
> Regards to your family and you A big hug from your
> Dalí.[7]

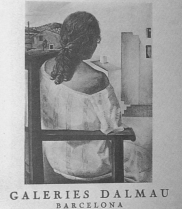

Catalogue of Dalí exhibition at Galeries Dalmau, November 1925.
Josep M. Joan, Figueres (no.148).

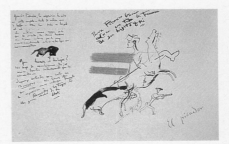

Letter from Dalí to Federico García Lorca, late November 1925, with drawing of Picador.
Fundación Federico García Lorca, Madrid (no.134).

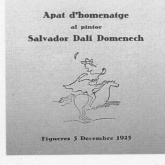

Invitation to banquet in honour of Dalí at the Gifré restaurant, Figueres, 5 December 1925 (no.147).

Photo of Dalí, c.1925, which he gave to Lorca.
Fundación Federico García Lorca, Madrid.

1926

Advertisement designed by Dalí which appeared on the back cover of the magazine *Residencia*, 1926.

January: Dalí participates in the exhibition of 'Modern Catalan Art' sponsored by the *Heraldo de Madrid* at the salon of the Círculo de Bellas Artes in Madrid, where he exhibits two works: *Girl at the Window* (see p.83) and *Venus and Sailor (Homage to Salvat-Papasseit)* (no.61). The latter was purchased by the painter Daniel Vázquez Díaz who, indirectly, in failing to be appointed Professor at the Academy, had provoked Dalí's temporary expulsion from the school.

April: He contributes drawings to several magazines: *Alfar* in La Coruña, *Residencia* (no.3) in Madrid and *Litoral* in Málaga. Lorca's poem 'Ode to Salvador Dalí' is published in the June issue of *Revista de Occidente*.

11–28 April: Dalí travels to Paris and Brussels with his aunt (step-mother) and his sister. It is on this trip that Manuel Ángeles Ortiz, whom he has got to know through Lorca, introduces him to Picasso, to whom he shows two works: *Girl from Figueres* (see p.136) and *Departure (Homage to Fox Newsreel)* (see p.92). In Paris, accompanied by Luis Buñuel, they visit galleries, attend 'tertulias' held by Spanish painters in the Café de la Rotonde, see Millet's studio-house in Fontainebleau, and also visit Versailles and the Louvre. They continue on to Brussels where they go to the Musées Royaux.

14 June: At the Special School Dalí refuses to be examined in 'Fine Art Theory' and declares that the board is not competent to examine him. The immediate order for his expulsion, set out in a document signed the same day, is confirmed by royal decree following a meeting of the school's Disciplinary Council on 20 October. Nonetheless, according to the official academic records, he had made good use of his time at the school.

He returns to Figueres and devotes himself totally to painting.

He illustrates *L'oncle Vicents* by J. Puig Pujades, published by Editorial Políglota in Barcelona (no.130).

Manuscript of Lorca's *Ode to Salvador Dalí*, 1926. Fundación Federico García Lorca, Madrid (no.137).

Certificate of Dalí's expulsion from the Special School of Painting, Sculpture and Engraving, 17 June 1926.

Dalí's academic file from the Special School, 1926.

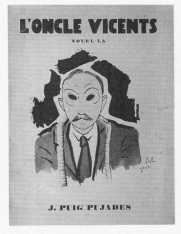

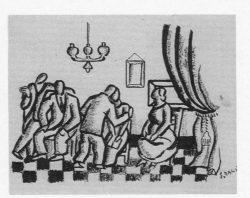

Title-page from the published edition of *L'Oncle Vicents*, 1926.

Illustration by Dalí for J. Puig Pujades's *L'Oncle Vicents*, 1926, ink on paper. The Salvador Dalí Museum, St. Petersburg, Florida (no. 130).

October: Dalí takes part in the first Autumn Salon (Saló de Tardor) at the Establiments Maragall (Sala Parés) in Barcelona. He exhibits two paintings: *Girl Sewing* (see p.136) and *Figure on the Rocks* (no.77).

16 October–6 November: He exhibits together with other artists (Robert Delaunay, Raoul Dufy, Albert Gleizes, Francis Picabia, Rafael Barradas, Joan Miró, Manolo Hugué, Ramon Pichot ...) in an 'Exhibition of Catalan pictorial modernisme compared with a selection of works by foreign avant-garde artists' at the Galeries Dalmau. He shows a *Still Life* (no.85) and two paintings entitled *Figure* (including 81).

In December he does two illustrations for 'Conte de Nadal' (Christmas Story) by J.V. Foix, published in the magazine *L'Amic de les Arts* (Sitges).[8]

Dalí. Illustrations for J.V.Foix's 'Conte de Nadal', published in *L'Amic de les Arts*, no.9, 31 December 1926.

1927

31 December (1926)–14 January: Dalí has his second one-man show at Galeries Dalmau in Barcelona, showing twenty-one paintings – *Composition with Three Figures (Neocubist Academy)* (see p.88), *Anna Maria* (painting on copper), *Girl with Curls*, *Girl Sewing* (see p.136), *Basket of Bread* (no.71), *Landscape of the Port at Cadaqués*, *Rocks at Llaner*, *Figure on the Rocks* (no.77), *Girl from Figueres* (see p.136), *Cliffs* (no.76), *Departure (Homage to Fox Newsreel)* (see p.92), three *Still Lifes* (probably no.82, no.85 and another), *Harlequin*, *Two Figures*, *Still Life (Invitation to Sleep)*, *Figures Lying in the Sand*, *Table by the Sea* (i.e., no.83), *Head*, *Guitar*, *Watermelon and Mandolin* (see p.93) and *Figures Running on the Beach* – and seven drawings – three described as *Study for the Painting of Anna Maria* (perhaps including nos.73,75), *Nude*, *Fish* (drawing in colour), *Portraits* and *Figures*.

In the 28 February 1927 issue of *L'Amic de les Arts* Sebastià Gasch writes:

> We believe with Benet, who expressed this in *La Veu*, that the genuine, characteristic, sincere Dalí is the Dalí of *Venus and the Sailor* [no.61], and the Dalí of the *Neocubist Academy* [see p.88] and the Dalí of *Figure on the Rocks* [no.77]. Within the confines of this style Dalí has realized works that are almost perfect. However, we believe that Dalí does not have to force his character, that this character does not have to force itself unnecessarily, and that he has to make an effort, within this intelligent neoclassicism, to surpass the victories he has won and to temper his logic with a breath of humanity.
> Recently, however, Dalí, who has his modish side, has allowed himself to be led by fashion and has plunged wildly into the painting of canvases in the style of Picasso's most recent works [...]

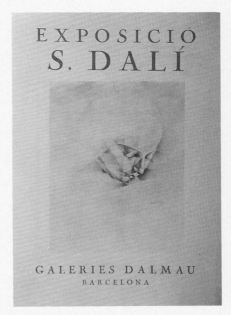

Catalogue of Dalí exhibition at Galeries Dalmau, Barcelona, December 1926 – January 1927 (no.149).

It is this exhibition that causes Picasso's dealer, Paul Rosenberg, to write to Dalí declaring an interest in his work, a letter to which he did not reply. Soon afterwards in a letter to Lorca he outlines his current preoccupations:

> Dear Federico:
>
> I have spent almost a month in Barcelona for my exhibition, now I am happily back in Figueres once again with a new stock of records for the phonograph and an infinity of old and new things to read.
>
> And with many paintings at my *fingertips* not just in my head.
>
> As you can see, I 'invite' you to my new type of St Sebastian, consisting in the pure transmutation of the Arrow by the Sole. The principle of elegance is what made St Sebastian agonize so deliciously. So it is an anti-elegant feeling that made him *convalesce so cravenly*; it had to have been like that – I would recommend it to you for a time, perhaps with the new change we will once again reach the true icy temperatures of the arrows of our old St Sebastian.
>
> St Rigol has spoken of you and of many other things too. I hope that the publication of your extraordinary books is true.
>
> Did you get a copy of *Gaseta de les Arts* with reproductions?
>
> Goodbye. *Regards* to the select folk of the *Litoral*.
>
> I hope to have news of you. Why do you write to me so rarely?
>
> The other day in Hospitalet Barradas showed me a 'clownist' portrait of you and Maroto. I almost burst into tears. What a chocolate Suchard of a little Japanese you are![9]

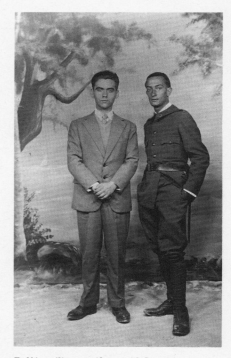

Dalí in military uniform with Lorca in Figueres, 1927. Fundación Federico García Lorca, Madrid.

1 February: Dalí begins his twelve months of military service at the Castle of San Fernando in Figueres.

12 March: *The Family of Harlequin*, a play written and directed by Adrià Gual opens at the Teatre Íntim in Barcelona. Adrià Gual (Barcelona, 1872 – Barcelona, 1943), painter, dramatist and film director was one of the most distinguished reformers of the Catalan theatre. *The Family of Harlequin* is presented as a 'meeting of theatrical investigation', with designs by Salvador Dalí.

24 June: *Mariana Pineda* by Federico García Lorca opens at the Teatre Goya in Barcelona with set designs and costumes by Dalí. On the following morning an exhibition of Lorca's drawings opens at Galeries Dalmau, sponsored by his Catalan friends. Salvador Dalí writes about this exhibition in the September issue of *La Nova Revista*:

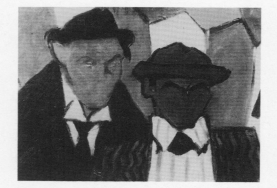

Rafael Barradas. *Federico García Lorca and Gabriel García Maroto*, 1922, oil on canvas, 47 × 64. Museo Nacional de Artes Plásticas, Montevideo.

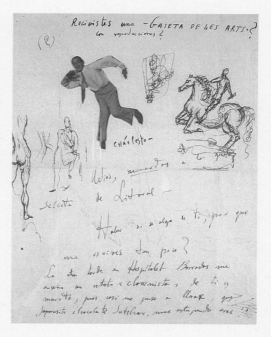

Page from letter from Salvador Dalí to Federico García Lorca, 18/20 January 1927. Fundación Federico García Lorca, Madrid (no.134).

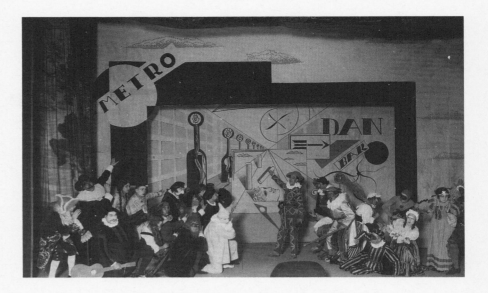

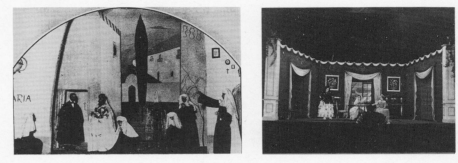

[...] The poetic system of Lorca's drawings tends towards an organic immateriality governed by a very pure and physiological calligraphic quality. Lorca, a pure-bred Andalusian, has an ancestral feeling for the relationships of colour and architecture poured out in an untrammelled harmonic assymetry that characterizes all the purest Oriental art.

31 July: In *L'Amic de les Arts* Dalí publishes 'Saint Sebastian' (see p.140), dedicated to Lorca, in which he establishes the basis for a new aesthetic, having its pictorial equivalent that same year in *Honey is Sweeter than Blood* (see p.169). This text is the first of Dalí's regular and extensive contributions to *L'Amic de les Arts*, which continue until 1929.

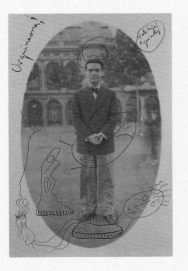

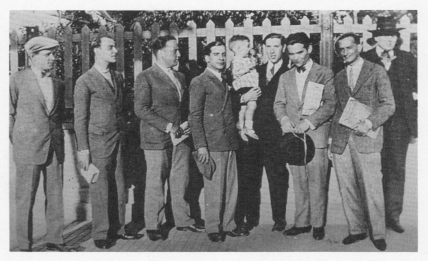

Federico García Lorca and contributors to *L'Amic de les Arts*: Manuel Font, J.V.Foix, Sebastià Gasch, Lluís Montanyà, Josep Carbonell, Lorca, Dalí, M.A.Cassanyes, 1928 (no.166).

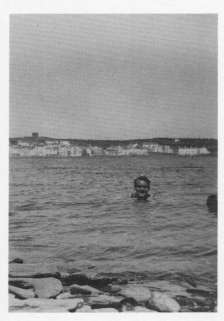

Lorca swimming in the bay at Cadaqués, 1927.

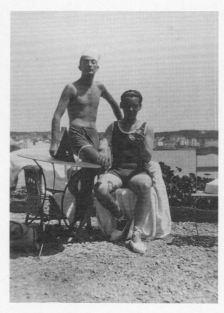

Dalí and Lorca at Cadaqués, 1927.

Anna Maria Dalí on the rocks at Cadaqués, 1927.

Dalí spends the summer in Cadaqués, where he is visited by Lorca and the guitarist Regino Sáinz de la Maza.

September: He is visited in Figueres by Joan Miró and Pierre Loeb, Miró's dealer. Both are very impressed by Dalí's most recent works, *Gadget and Hand* (no.97) and *Honey is Sweeter than Blood* and decide to stay in touch. A few months later Miró writes to confirm his positive impression:

Letter from Joan Miró to Dalí, 19 December 1927.

> Dear Dalí, Very pleased indeed to have received your drawings.
> You are, without doubt, a very gifted man with a brilliant career in prospect, *in Paris*.
> Pierre has also written to me; very impressed and seems to be very well disposed towards you.
> He wrote to me recently telling me he had sent some of your photos to Zervos of 'Cahiers d'Art'.
> I think we have everything very well prepared, and that we must just keep *striking the iron* every minute.
> Have you sent those last drawings to Pierre? I'd be glad if you would – I'd like to keep my ones to show personally to other people.
> Before leaving I'd like to ask you for photos of your things from other periods or done in different moods. I think it's very important that I know those too.
> Finally, don't fail to act, insistently but without a trace of impatience.
> Wishing you good health, I am happy to be your good friend and comrade,
> Miró.

Loeb, however, is not as interested as Miró, as he had previously written to Dalí:

> Dear Sir,
> I received your photos with interest; please continue to send them to me. I do see a possibility of taking you on, but I find you are still veering too rapidly from one influence to another and I am waiting for the opening up of your own personality. I am sure you will soon find a *direction* and with your gifts I feel certain that you will have a fine career as a painter.
> In any case, I am following you closely.
> With best wishes
> Pierre

Letter from Pierre Loeb to Dalí, 7 December 1927.

33

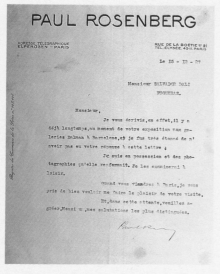

Letter from Paul Rosenberg to Dalí,
15 December 1927.

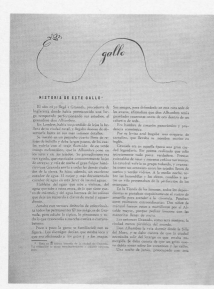

Dalí. Emblem for Lorca's magazine *gallo*,
1928.

During the same period Paul Rosenberg renews his interest in Dalí's work:

> Sir,
> I wrote to you, in fact, some time ago, at the time of your exhibition at the Galeries Dalmau in Barcelona, and I was very surprised not to have received your reply to this letter.
> I have in my possession the photographs that were enclosed. I shall examine these at leisure.
> When you come to Paris, please oblige me with a visit.
> In this expectation, I remain, sir, yours sincerely,
> Paul Rosenberg.

October: Dalí participates in the Autumn Salon organized by the Sala Parés in Barcelona, where he exhibits *Gadget and Hand* (no.97) and *Honey is Sweeter than Blood* (see p.169).

He does illustrations for 'Del cine en el sistema de las bellas artes', an article by Alexandre Plana that appears in *Nova Revista*, Barcelona (July, no.7).

1928

January: Dalí participates in the group exhibition 'Manifestación de arte de vanguardia' at Galeries Dalmau. Also included are Rafael Barradas, Josep Gausachs, Enric C. Ricart, Magí Cassanyes, Xavier Güell and the sculptors Narcís Cuyàs and Josep Moya Ketterer. Dalí shows *Male and Female Figures on a Beach* (see p.147), *Female Nude* (see p.146) and *Two Figures on a Beach*.

February: Lorca publishes *gallo* in Granada, a little magazine inspired by Surrealism. Two numbers are issued. Dalí designs the cockerel emblem as well as doing all the illustrations for the first issue.

In the same month Marinetti gives a lecture at the Teatre Tívoli in Barcelona. In an interview the Italian writer singled out Dalí as one of his followers in Catalunya.

March: Dalí, Lluís Montanyà and Sebastià Gasch publish *Manifest Groc – Manifest antiartístic català (Yellow Manifesto – Catalan Anti-Artistic Manifesto)*. His friends in Granada translate and publish it in the second issue of *gallo* and refer to it as 'the most interesting example of contemporary Catalan youth culture.' The *Yellow Manifesto* begins:

> We have eliminated from the **MANIFESTO** all courtesy in our attitude. It is useless to attempt any discussion with the representatives of present-day Catalan culture, which is artistically negative although efficient in other respects. Compromise and correctness lead to deliquescent and lamentable states of confusion of all values, to the most unbreathable spiritual atmospheres, to the most pernicious of influences.

The Manifesto provokes a great deal of hostile reaction and is considered by many to be futurist and, therefore, no longer in fashion.[10]

13 May: The journal *L'Amic de les Arts* organizes 'El Centaure' in the Ateneu in Sitges, a conference at which the speakers are Josep Carbonell, J.V.Foix, Sebastià Gasch and Salvador Dalí. Its purpose is to expose the public to the most recent trends in modern art. Dalí's is the most daring contribution: he proposes, among other things, the demolition of the Gothic Quarter in Barcelona, to be replaced by architecture of reinforced concrete, the abolition of the *sardana*, Catalunya's national dance, and a stand against anything that could be considered regional.

Opposite: Salvador Dalí, Lluís Montanyà, Sebastià Gasch. *Yellow Manifesto*, 1928 (no.150).

Del present **MANIFEST** hem eliminat tota cortesia en la nostra actitud. Inútil qualsevol discussió amb els representants de l'actual cultura catalana, negativa artísticament per bé que eficaç en d'altres ordres. La transigència o la correcció condueixen als deliqüescents i lamentables confusionismes de totes les valors, a les més irrespirables atmòsferes espirituals, a la més perniciosa de les influències. Exemple: «La Nova Revista». La violenta hostilitat, per contra, situa netament les valors i les posicions i crea un estat d'esperit higiènic.

HEM ELIMINAT	tota argumentació	⎧ Existeix una enorme bibliografia i tot l'esforç dels artistes d'avui per a suplir tot això.
HEM ELIMINAT	tota literatura	
HEM ELIMINAT	tota lírica	
HEM ELIMINAT	tota filosofia	
	a favor de les nostres idees	

ENS LIMITEM a la més objectiva enumeració de fets

ENS LIMITEM a assenyalar el grotesc i tristíssim espectacle de l'intel·lectualitat catalana d'avui, tancada en un ambient rescloït i putrefacte.

PREVENIM de la infecció als encara no contagiats. Afer d'estricta asèpsia espiritual.

SABEM que res de nou anem a dir. Ens consta, però, que és la base de tot el que avui hi ha i de tot el nou que tingui possibilitats de crear-se.

VIVIM una època nova, d'una intensitat poètica imprevista.

EL MAQUINISME ha revolucionat el món

EL MAQUINISME —antítesi del circumstancialment indispensable futurisme— ha verificat el canvi més profund que ha conegut la humanitat.

UNA MULTITUD anònima — anti-artística — col·labora amb el seu esforç quotidià a l'afirmació de la nova època, tot i vivint d'acord amb el seu temps.

UN ESTAT D'ESPERIT POST-MAQUINISTA HA ESTAT FORMAT

ELS ARTISTES d'avui han creat un art nou d'acord amb aquest estat d'esperit. D'acord amb llur època.

ACÍ, PERÒ, ES CONTINUA PASTURANT IDÍL·LICAMENT

LA CULTURA actual de Catalunya és inservible per a l'alegria de la nostra època. Res de més perillós, més fals i més adulterador.

PREGUNTEM
ALS INTEL·LECTUALS CATALANS:

—De què us ha servit la Fundació Bernat Metge, si després havem de confondre la Grècia antiga amb les ballarines pseudo-clàssiques?

AFIRMEM que els sportmen estan més aprop de l'esperit de Grècia que els nostres intel·lectuals

AFEGIREM que un sportman verge de nocions artístiques i de tota erudició està més a la vora i és més apte per a sentir l'art d'avui i la poesia d'avui, que no els intel·lectuals, miops i carregats d'una preparació negativa.

PER NOSALTRES Grècia es continua en l'acabat numèric d'un motor d'avió, en el teixit anti-artístic d'anònima manufactura anglesa destinat al golf, en el nu en el music-hall americà.

ANOTEM que el teatre ha deixat d'existir per a unes quants i gairebé per a tothom.

ANOTEM que els concerts, conferències i espectacles corrents avui dia entre nosaltres, acostumen a ésser sinònims de llocs irrespirables i avorridíssims.

PER CONTRA nous fets d'intensa alegria i jovialitat reclamen l'atenció dels joves d'avui.

HI HA el cinema

HI HA l'estadi, la boxa, el rugby, el tennis i els mil esports

HI HA la música popular d'avui: el jazz i la dansa actual

HI HA el saló de l'automòbil i de l'aeronàutica

HI HA els jocs a les platges

HI HA els concursos de bellesa a l'aire lliure

HI HA la desfilada de maniquins

HI HA el nu sota l'electricitat en el music-hall

HI HA la música moderna

HI HA l'autòdrom

HI HA les exposicions d'art dels artistes moderns

HI HA encara, una gran enginyeria i uns magnífics trasatlàntics

HI HA una arquitectura d'avui

HI HA útils, objectes, mobles d'època actual

HI HA la literatura moderna

HI HA els poetes moderns

HI HA el teatre modern

HI HA el gramòfon, que és una petita màquina

HI HA l'aparell de fotografiar, que és una altra petita màquina

HI HA diaris de rapidíssima i vastíssima informació

HI HA enciclopèdies d'una erudició extraordinària

HI HA la ciència en una gran activitat

HI HA la crítica, documentada i orientadora

HI HA etc., etc., etc.

HI HA finalment, una orella immòbil sobre un petit fum dret.

DENUNCIEM la influència sentimental dels llocs comuns racials de Guimerà

DENUNCIEM la sensibleria malaltissa servida per l'Orfeó Català, amb el seu repertori tronat de cançons populars adaptades i adulterades per la gent més absolutament negada per a la música, i àdhuc, de composicions originals. (Pensem amb l'optimisme del chor dels «Revellers» americans).

DENUNCIEM la manca absoluta de joventut dels nostres joves

DENUNCIEM la manca absoluta de decisió i d'audàcia

DENUNCIEM la por als nous fets, a les paraules, al risc del ridícul

DENUNCIEM el soporisme de l'ambient podrit de les penyes i els personalismes barrejats a l'art

DENUNCIEM l'absoluta indocumentació dels crítics respecte l'art d'avui i l'art d'ahir

DENUNCIEM els joves que pretenen repetir l'antiga pintura

DENUNCIEM els joves que pretenen imitar l'antiga literatura

DENUNCIEM l'arquitectura d'estil

DENUNCIEM l'art decoratiu que no sigui l'estandarditzat

DENUNCIEM el pintors d'arbres torts

DENUNCIEM la poesia catalana actual, feta dels més rebregats tòpics maragallians

DENUNCIEM les metzines artístiques per a ús infantil, tipus: «Jordi». (Per a l'alegria i comprensió dels nois, res de més adequat que Rousseau, Picasso, Chagall...)

DENUNCIEM la psicologia de les noies que canten: «Rosó, Rosó...»

DENUNCIEM la psicologia dels nois que canten: «Rosó, Rosó...»

FINALMENT ENS RECLAMEM DELS GRANS ARTISTES D'AVUI, dins les més diverses tendències i categories:

PICASSO, GRIS, OZENFANT, CHIRICO, JOAN MIRÓ, LIPCHITZ, BRANCUSI, ARP, LE CORBUSIER, REVERDY, TRISTAN TZARA, PAUL ELUARD, LOUIS ARAGON, ROBERT DESNOS, JEAN COCTEAU, GARCÍA LORCA, STRAWINSKY, MARITAIN, RAYNAL, ZERVOS, ANDRÉ BRETON, ETC., ETC.

SALVADOR DALÍ LLUÍS MONTANYÀ

SEBASTIÀ GASCH

Barcelona, març de 1928

IMP. FILLS DE F. SABATER

21 May: To accompany an exhibition of painting in the Casino Menestral in Figueres, in which Dalí exhibits nine works, among them *Still Life (Invitation to Sleep)*, *Gadget and Hand* (no.97), *Honey is Sweeter than Blood* (see p.169) and *Harlequin*, a lecture series is organized which Dalí is to close with a discourse on Surrealism. After the lecture and at the moment of his closing speech, the mayor of the town suddenly falls dead.

September: Owing to Dalí's unenthusiastic reception of the publication of Lorca's *Romancero Gitano*, the relationship between the two begins to cool. In a letter, which Santos Torroella dates to the beginning of 1928,[11] Dalí writes to his friend:

Dear Federico:

I have read your book calmly and I cannot refrain from making certain comments on it. Naturally, it's impossible for me to agree with anything the great putrefied swine have written about it, Andrenio, etc. etc. but I think that my views, which are becoming more *centred* on poetry every day, might be of some interest to you.

I. I think that the best of the book is the last bit, martyrdom of Santa Olalla, bits of the incestuous '*murmur of imprisoned rose*'. These things are free of mannerism, they are much less anecdotal than the rest, etc. The bit about the gentleman who '*takes her to the river*' seems to me the worst. The *charm* is a product of a state of mind based on appreciation sentimentally deformed by *anachronism*. The bit about the petticoats of the little saint in his bedroom, Saint Gabriel, is, for me, a kind of immorality, in that now I can only tolerate things that have come into being through *anger*, immorality of the sort employed by the French, by the French 'esprit', disgusting and inadmissible, Cocteau, etc., by which we have all become infected.

II. Your new poetry falls firmly within the *traditional*, in it I see signs of the *most fabulous poetic substance that has ever existed:* but! absolutely tied to the lyrical norms of the past, which are now incapable of moving us or satisfying our new desires. Your poetry is bound hand and foot to poetry of the past. You think perhaps that certain images are arresting or you may find an increased dose of the irrational in your stuff but I can tell you that your poetry is concerned with illustration of commonplaces of the most stereotyped and conformist kind.

I am convinced that effort in poetry today makes sense only in the escape from the ideas which our intelligence has forged artificially, and in the endowment of these ideas with their precise, real meaning.

In truth, there is no connection between two dancers and a honeycomb, unless it is the connection which exists between Saturn and the little caterpillar which sleeps in the chrysalis, or unless it is that in reality there exists *no difference at all* between the couple dancing and a honeycomb.

The minute hands of a clock (and don't take any notice of my examples as I'm not looking for anything particularly poetic) begin to have real value at the moment when they cease to signify clock-time and, losing their *circular* rhythm and the arbitrary mission to which our intelligence has subjected them (indicating time), they *escape* the clock to articulate the site belonging to the sex of little breadcrumbs.

You move among accepted and anti-poetic notions. You speak of a rider and you already assume that he rides a horse and that the horse gallops; *that is saying a lot* because in *reality* it would be *important to find out* if it really is the rider who is riding, if the reins are not just a

Above and opposite: Letter from Dalí to Lorca, September 1928. Fundación Federico García Lorca, Madrid (no.134)

continuation of his *very own* hands, if in reality the little hairs on the rider's balls are not faster than the horse, and to find out if the horse is not actually something motionless attached to the ground by vigorous roots, etc., etc. Think, then, what it is to get to your idea of the 'guardia civil'. Poetically, a civil guard does not exist in reality, unless he is a happy and pretty silhouette, alive and sparkling with little peaks that stick out of him on all sides and little straps that are a visceral part of the same little beast, etc., etc. But you ..., rottenly – the civil guard – what does he do? such, such, such, such unreality, unreality.

– Anti-poetry –

A formulation of arbitrary notions of things.

One has to allow things to be *free* of the conventional ideas which the intellect forces on them. Then these charming little things will work by themselves in accordance with their real and *consubstantial* manner of being. Let them decide the direction of the projection of their own shadows: And perhaps what we thought would cast a strong shadow won't cast a shadow at all, etc., etc. Ugly – pretty? Words that have utterly lost their meaning. Horror, that's another thing, that's what comes from knowing reality, far from *aesthetics*, as lyricism is only possible in the more or less approximate notions that our intellect can perceive from reality.

An *article* devoted to you *will come out* in the *Gaceta* in which I talk about all this and also about strictly objective fact obtained anti-artistically by a rigorous analytical method. But let's let it drop; I'm becoming less and less capable of writing like this in letters but, on the other hand, I write long and substantial articles full of ideas.

Federiquito, in your book which I've taken with me to the mineral places round here to read, I've seen you, little beastie that you are, little erotic beastie, with your sex and the *little* eyes *of your body* and your hairs and your terror of death and your wish that if you die *gentlemen will know about it*, your mysterious spirit made up of silly little *enigmas* and of close astrological correspondences; your thumb in close correspondence with your prick and with the dampness of the lakes of saliva of certain species of *hairy planets* that exist. I love you for what your book reveals you to be, which is quite the opposite of the idea the putrid philistines have put out about you, that is a bronzed gypsy with black hair, childish heart, etc. etc. A *Nestorian* Lorca, decorative, anti-real, non-existent could only have been created by filthy artists, far away from the little hairs and the little bears and the soft silhouettes, hard and liquid, that surround us, etc. etc. You, little beastie, with your little fingernails, with your body sometimes half possessed by death, in which death wells up from your nails to your shoulders in the most sterile of efforts! I have drunk death against your shoulder in those moments when you abandoned your great arms, which had become like two crumpled empty sheaths of the insensitive and useless folds of the tapestries ironed at the Residencia, ... to you, to the Sole that I see in your book, that great Sole that I love and admire ... The day you lose your fear and shit on the Salinases of the world, give up RHYME, in short, Art as understood by the swine – you'll produce witty, horrifying, (illegible), intense, poetic things such as no other poet could.

Goodbye. I BELIEVE, in your inspiration, in your *sweat,* in your astronomical fatality.

This winter (?) I invite you to throw ourselves into the *void*. I've

already been there for sometime; I've never felt so secure. Now I know something about *Statuary* and REAL clarity, now, far away from any Aesthetic.

Hugs,

DALÍ

Surrealism is *one* of the means of Escape.

But it's Escape *itself* that is the important thing.

I'm beginning to have my own modes apart from Surrealism, but the latter is something alive. As you can see, I no longer talk about it as I used to, and I am delighted to say that my views have changed very considerably since. How about that, eh?[12]

Lorca told Sebastià Gasch he considered Dalí's letter 'intelligent and arbitrary' and that it raised 'an interesting poetic issue'. Though the two friends were now physically separated, there was no ill-feeling between them, as is clear from the illustration that Dalí did for a poem of Lorca's in *La Gaceta Literaria* (1 Jan. 1929) and from the letter that the poet sent to him on returning from New York (in the late autumn of 1930):

My very dear friend Salvador:

How long has it been since we last saw each other? I want to speak to you and, what's more, I need to speak to you. I have lived splendidly in New York for a year and now I find that as I don't know you I don't know what I have to say. But it is surely this: In January I will have a lot of money and I am inviting you right now to come with me to New York. You could stay there for six months and then return to Paris or you could travel to Moscow with me. I am going to have an exhibition in New York as I already have a gallery and an enormous quantity of idiot friends, millionaire pansies and ladies who buy new paintings and will make our winter a pleasant one. You know how I can turn on the charm. I think it could be useful for you and your marvellous spirit will see things never seen before in this totally new city, such a contrast, both in its form and its dream, to the reborn but already putrid romanticism in Paris.

I burn with longing to see your new things. Send me photographs and tell me what you have been doing.

I have worked a lot, with much labour and much happiness.

I want you to see my new things, such as the film that I've made with a black poet in New York that will open when I return in a wonderful cinema on eighth street where all the Russian and German productions are shown.

I want to speak to you. I have lived out of touch with your friendship for too long.

Tell me what you think. Write to me at length.

Goodbye. ever yours.

Federico

Once I have broken my chain of stupidity when I go to bed at night I feel stronger than ever and more of a poet than anyone.

His house is the Acera de Casino 31

I was very amused by the way in which you were going to swindle my family and it's a shame they didn't send you the money. I found out too late as the letter was forwarded me, otherwise I would have wired you the cash.

Write to me!

Dalí. Illustration for Lorca's 'Decapitation of the Innocents', published in *La Gaceta Literaria*, 15 January 1929.

Letter from Lorca to Dalí, late 1930.
Fundación Federico García Lorca, Madrid.

Letter from Joan Anton Maragall to Dalí,
3 October 1928.

6–28 October: Dalí participates in the third Autumn Salon at the Sala Parés. Dalí submits two works, *Thumb, Beach, Moon and Decaying Bird* (see p.134) and *Figures on a Beach* (subsequently titled *Ungratified Desires*, see p.146), but the director of the gallery, Joan Maragall, feels that the latter should not be shown; he considers its subject-matter obscene, as he explains in a letter to the painter, dated 3 October:

> Distinguished friend,
> I have just received your two canvases. I am not writing now to tell you how much I value the very many qualities that I find in both of them. But I have to write from a point of view completely removed from my personal opinion. It is very difficult to exhibit one of your paintings, if I am to prevent my Gallery becoming involved in a series of arguments which would damage a success that I believe everyone has to support. I very much wish that you were in my place and that you would imagine what it means for the Barcelona public to be invited to an exhibition in which they would find a picture that would disgust them to the core of their being. I wish you were in my place and were able to understand how very difficult it is to write this to you, how much I would like to say nothing to you and exhibit the picture. I would be very grateful if you would release me from this predicament by allowing me not to exhibit this work of yours, much as I would regret this. I am sure of this and look forward to your telephoning me or leaving a message.
> I remain always your firm friend
> Joan Maragall

Dalí at first refuses to exhibit any canvases at all or give a lecture that had been planned, though he subsequently relents, agreeing to exhibit only the one work and to deliver a lecture on 16 October entitled, 'Contemporary Catalan Art and its Relationship to the Latest Youthful Intelligence', which arouses considerable controversy.

18 October–18 December: Dalí participates in the '27th International' in Pittsburgh (the Carnegie Prize). He is represented by three works: *Basket of Bread* (no.71), *Seated Girl Seen from the Back* (no.66) and *Anna Maria*.

22 October–6 November: He takes part in the show that opens the winter season at Galeries Dalmau in Barcelona, exhibiting three works: *Male and Female Figures on a Beach* (see p.147), *Female Nude* (see p.146) and *Two Figures on a Beach*, all of which had been exhibited there at the beginning of the year.

In January Salvador Dalí and Luis Buñuel meet in Figueres to write the script for a film with the provisional title, *Dangereux de se pencher en dedans [Dangerous to lean inside]*. Using this initial script, finally to be called *Un Chien andalou [An Andalusian Dog]*, Luis Buñuel shoots the film in Paris between 2 and 17 April.

20 March: An Exhibition of Painting and Sculpure by Spanish artists resident in Paris, organized by the Sociedad de Cursos y Conferencias, opens at the Botanical Gardens in Madrid. The four paintings by Salvador Dalí stand out: *Sterile Attempts* – later to be retitled *Little Ashes* (no.98), *Female Nude* (see p.146), *Honey is Sweeter than Blood* (see p.169) and *Male and Female Figures on a Beach* (see p.147).

31 March: The final issue (no.31) of the avant-garde journal *L'Amic de les Arts* appears (the penultimate issue had appeared on 31 December 1928). It is conceived by Dalí, who uses it to make a profession of surrealist faith.

In the first fortnight of April the painter goes to Paris (where he remains until the beginning of June), to help with the filming of *Un Chien andalou*. The visit gives him an ideal opportunity to implement the advice Miró gave in a letter he had written to him:

> It seems to me a mistake for you to think of holding an exhibition in Paris, without coming here first and preparing the ground *yourself*. If you don't do this it's almost certain to pass virtually unnoticed, neutralizing your attack and at the same time removing you from the action for a long time, since an exhibition which is to have a *real sting* needs more than weeks or even months to prepare.
>
> I think the right thing would be to come here for a few months and prepare the ground; I have friends here who think highly of you, all of whom would do everything they can to give us ammunition.
>
> I think that in the country of *bon sens* and *belle prudence* they won't make up their minds if something is male or female [commit themselves] before having seen it from the back, as the peasants at home do to make sure they don't get trapped.
>
> Fundamentally, I think people here are as cowardly as in the land of *seny* [Catalan level-headedness] (!!). You can only make an impression through f*ear* and then by whipping them, and for that reason you have to collect dues from them in advance and without *rushing* them.
>
> Forgive me if I am voicing an idea which perhaps you don't agree with, but since you asked me I am giving you my honest opinion.
>
> If you come in May I'll be in Brussels, but only for a week; let me know in advance when you're coming.
>
> Yesterday evening I met your friend Buñuel; he is one of the nicest people I have met. We talked a lot about you and Gasch.
>
> Greetings to your father, yours
> Miró

Letter from Joan Miró to Dalí, 13 March 1929.

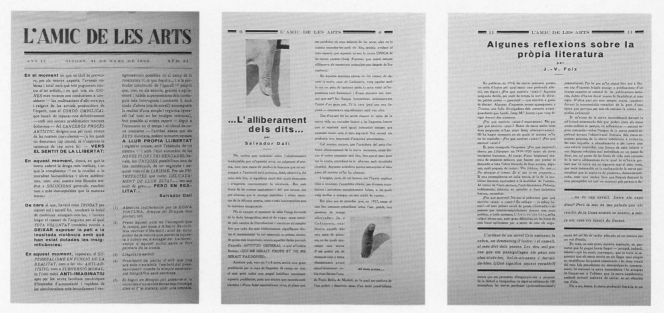

Pages from final number of *L'Amic de les Arts*, edited by Dalí, 31 March 1929.

Once he has arrived in Paris, Miró introduces Dalí to the social life of the capital and puts him in touch with Tristan Tzara and the surrealist group, of whose activities he is already well aware through a variety of periodicals. He meets Magritte, Arp and Camille Goemans, his future dealer, who introduces him to Paul Eluard. He signs a contract with Goemans and commits himself to an exhibition in the Autumn.

During his stay in Paris he writes a series of articles (six) for the Barcelona newspaper *La Publicitat* in which, under the title 'Documental–Paris–1929', he describes his successive discoveries, appreciations of new poets, of the paintings that have most impressed him and writes about the rumours surrounding *Un Chien andalou* in Paris.

6 June: *Un Chien andalou* is previewed at the Studio des Ursulines cinema. It is shown at the mansion of the Vicomte and Vicomtesse de Noailles on 3 July, and at the beginning of September at a cinematographic conference in the Swiss town of La Sarraz where, according to Dalí, it is praised by Sergei M. Eisenstein. On 1 October it opens to the public at Studio 28 in Paris and runs for eight months. The film director Jean Vigo is impressed by the film and writes:

> Shame on those who killed at puberty what they would have been able
> to become and what they search for all along the wood and the shore,
> so that what they are when spring comes is dried up. *Cave canem* ...
> beware of the dog, it bites ...[15]

Gala Eluard. Photograph by
Man Ray (no.168).

Dalí spends the summer in Cadaqués and is visited there by Goemans and his girl-friend, René Magritte and his wife, Luis Buñuel, Paul Eluard and his wife Gala with their daughter, Cécile. In September the group returns to Paris, but Gala stays on for a few more weeks in Cadaqués with Dalí.

6 October – 3 November: Dalí participates in the group exhibition 'Abstrakte und Surrealistiche Malerei und Plastik' organized by the dissident surrealist group *Documents* at the Zürich Kunsthaus. Dalí exhibits *Female Nude [Beigneuse]* (no.105) and *Bathers* (see p.146); among the other artists exhibiting are Arp, Brancusi, de Chirico, Ernst, Gris, Kandinsky, Klee, Magritte, Masson, Miró, Mondrian, Picabia and Picasso.

20 November – 5 December: Dalí's first one-man show in Paris is held at the Goemans Gallery. He exhibits eleven paintings: *Dismal Sport* (see p.151), *Accommodations of Desire* (no.116), *Illumined Pleasures* (no.114), *The Sacred Heart* (no.109), *The Enigma of Desire, The Face of the Great Masturbator* (i.e., no.112), *The First Days of Spring* (no.110), *Man with an Unhealthy Complexion Listening to the Sound of the Sea* (no.111), *Portrait of Paul Eluard* (see p.155), *Sterile Attempts* (i.e., no.98) and *Gadget and Hand* (no.97); and several drawings.

André Breton writes the introduction to the catalogue. Dalí does not attend the opening, having left two days earlier for Barcelona and Sitges with Gala. On 25 November Tériade writes in *L'Intransigeant*:

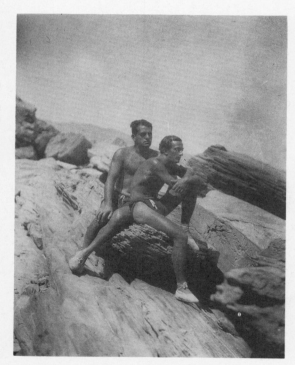

Luis Buñuel and Dalí in Cadaqués, 1929.
Collection Robert Descharnes.

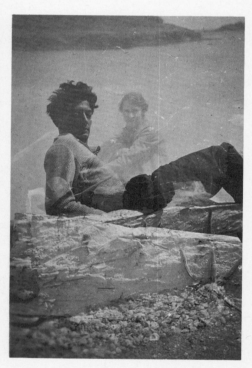

Self-portrait photograph of Dalí at Cadaqués with a
photograph of Gala Eluard superimposed.

How dated it all seems, provincial, provincial despair, in fact, wanting to be up to the minute. Two years ago it might still have made an impression. This young Catalan surfeited on surrealist literature, on surrealist reproductions and on youthful enthusiasm is coming to conquer Paris. He shows us fantasies which have a stale family smell, the smell of revolutionary posturing, ultimately very 'nervous child' with all kinds of virtuosity making feet and hands to astound us. The success he may achieve among a few neurotics or with a few chefs d'école, available because they have been sacked, will give him ready consolation for the fact that we find his painting entirely lacking in any mystery other than that of the kitchen which is, as we know, a mystery of compromises and of recipes within reach of everybody. As Dalí seems to have talent, a talent which is still undefined, as he is intelligent, imaginative, daring, he will certainly succeed in doing something one day, but if it is to be in painting we would advise him to mistrust all the qualities which he has on display today. It is the precise opposite of those qualities which make the painter.

29 November–6 December: Buñuel joins Dalí in Cadaqués to work on the script of their new film, *L'Âge d'or*, then titled *La Bête andalouse [The Andalusian Beast]*, which is to be produced by the Vicomte de Noailles.

15 December: The final issue (no.12) of the journal *La Révolution Surréaliste* publishes Dalí and Buñuel's script for *Un Chien andalou*.

At the end of the year Dalí has a heated exchange with his father occasioned by the article entitled 'Dismal Sport and the Double Game' published by Eugeni d'Ors in *La Gaceta Literaria* (15 Dec. 1929), in which the author explains that among the works exhibited at the Galerie Goemans in Paris was a canvas of the Sacred Heart inscribed by Dalí with the following words: 'Parfois je crache par plaisir sur le portrait de ma mère' ('Sometime I spit for pleasure on the portrait of my mother'). Dalí's father demands that the young painter withdraw the insult; he refuses and as a result of the ensuing quarrel returns hurriedly to Paris, where he continues his discussions with Buñuel on the script of *L'Âge d'or*.

1930

10 January: Dalí and Gala leave for the south of France. They spend several months in a studio at the Hôtel du Château in Carry-le-Rouet, near Marseille, where he begins work on *The Invisible Man* (no.123), a painting on which he continues to work until 1933 but which remains unfinished. At the same time he writes *La Femme Visible [The Visible Woman]* (no.132), published later in the year.

March: He receives a letter from the Vicomte de Noailles offering financial assistance since it seems likely that the Goemans Gallery is on the point of closing. Since Dalí wants to be able to live in peace so as to paint undisturbed, he sends Gala to Paris to recover the money still owed to him by his gallery and he visits the Vicomte in his château at Saint-Bernard-en-Hyères, to propose a deal: he agrees to sell any painting Charles de Noailles chooses for the sum of 20.000F. The Vicomte selects *The Old Age of William Tell* and Dalí uses the money to buy a fisherman's cottage in Port Lligat, close to Cadaqués.

In connection with this purchase, he arrives in Cadaqués with Gala at the beginning of March. It is probably this visit which occasions the letter Dalí's father writes to Buñuel:

Señor Luis Buñuel
 My dear friend:
 I presume you have received my letter of last Saturday. If you are still friendly with my son, would you do me a favour. I am not writing to him as I do not have his address.
 Yesterday he came through Figueres, according to reports I have received, and left for Cadaqués with la madame. He had the

opportunity of staying in Cadaqués for only a couple of hours, because in the afternoon the *guardia civil*, following orders they had been given, visited him. He avoided an unpleasant situation, since if he had stayed in Cadaqués things would have gone badly for him.

He left yesterday afternoon or evening for Paris, where I think he will stay a week. Since you will know la madame's address, you could inform him (my son) that he should not try to return to Cadaqués for the simple reason that he will not be able to stay in said village, not even for two or three hours. Matters would also be complicated in such a way that he would be unable to return to France.

All the problems he is having are his fault (that of my son) and I assume you will apprise him of this.

My son has no right to embitter my life. Cadaqués is my spiritual refuge. My peace of mind is disturbed by the presence of my son in said village. Moreover, the place where my wife goes to restore her health will be destroyed if my son sullies it with his foul conduct.

I am not willing to suffer any more. For this reason I have organized everything so that I will not be bothered during this summer. This very day I have taken adequate measures to prevent my son from soiling us this summer or the following one. When these measures are no longer effective, I will have recourse to everything that is available to me, including personal attack. My son will not go to Cadaqués, he must not go, he cannot go. Neither this summer nor next, because I have other means of preventing him from bothering me. Because when the measures I am taking today are no longer effective, it will be necessary for the two of us to come to blows to see which one will win, and I warn him that since I intend to win at all costs, this will give me the advantage, as I will be employing people to help me attack him, or looking for opportunities to attack without being attacked myself. This is not cowardice, as I am making my intentions known to the victim, and, as a consequence, if he wishes to go to Cadaqués he will have to take every precaution to defend himself or to go on the offensive (whichever he wants to do).

Your theories have convinced me completely. He believes that in the world it is a question of doing all possible evil, and I believe this too. As for spiritual evil, I can do him none, since he is a man who is completely degraded, but I can cause him physical harm because he *still* has flesh and bones.

22 March: Dalí delivers a lecture at the Ateneu in Barcelona on 'The Moral Position of Surrealism'.

28 March–12 April: Dalí takes part in the last exhibition held at the Goemans gallery, an exhibition of collages organized in collaboration with Louis Aragon, who writes the catalogue introduction. He shows *The First Days of Spring* (no.110). Other artists in the exhibition include Arp, Braque, Duchamp, Ernst, Gris, Miró, Magritte, Man Ray, Picabia, Picasso and Tanguy.

Dalí at the door of his house at Port Lligat.

Frontispiece for the *Second Surrealist Manifesto*, 1930
(see no.119).

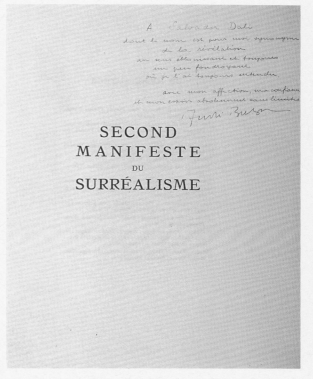

André Breton's dedication to Dalí on his copy of the *Second
Surrealist Manifesto*, 1930 (no.152)

Dalí's relationship with the surrealist group, and with André Breton in particular,
becomes more intense. Breton sees the young painter as a force for renewal in a
movement plagued by internal struggles: Dalí designs the frontispiece for Breton's
Second Surrealist Manifesto (Simon Kra, Paris, 1930) and illustrates *The Immaculate
Conception* by Breton and Eluard (José Corti, Paris, 1930) and *Artine* by René Char
(Editions Surréalistes, Paris, 1930). Breton dedicates a copy of the *Second Manifesto*
to him with the following words:

> To Salvador Dalí
> whose name is synonymous for me with revelation in the sense of
> dazzling and overwhelming that I have always understood the word to
> mean, with my affection, my confidence and the absolutely boundless
> hopes he inspires in me.

June: Dalí meets Alfred H. Barr, director of the Museum of Modern Art in New York,
at the home of the Vicomte de Noailles. Barr shows an interest in his work and
encourages him to visit the United States.

21 June: He signs a contract with Pierre Colle, to whom he had been recommended
by the Vicomte de Noailles.

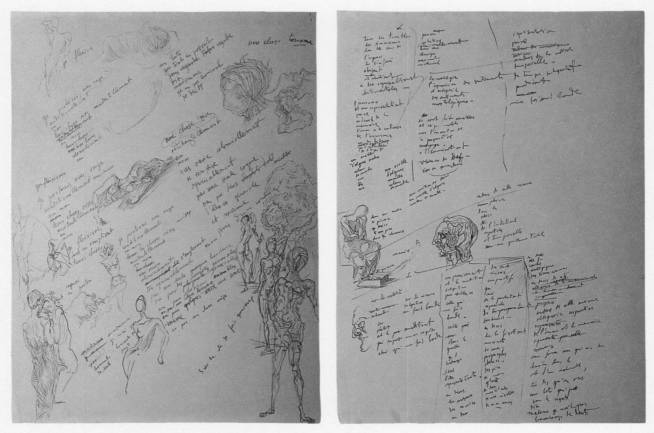

Dalí. *L'Amour et la mémoire*, pages of manuscript with drawings, 1930 (no.131).

Summer: He returns to Cadaqués, despite his father's threats, and settles with Gala in Port Lligat. They begin to renovate the fisherman's cottage they have purchased. (Later, over a period of years, they enlarge and extend this and live there from spring to autumn each year.) Gala falls ill with pleurisy and they decide to move to Málaga during her convalescence.

Dalí's book *L'Amour et la mémoire [Love and Memory]* (no.130) is published by Editions Surréalistes.

The first surrealist exhibition in the United States is held at the Wadsworth Athenaeum in Hartford, Conn. Dalí is represented by eight paintings and two drawings.

22 October: *L'Âge d'or* is previewed at the Panthéon cinema in Paris; the script is by Buñuel and Dalí, and it is produced by the Vicomte de Noailles. Buñuel goes to Hollywood a week later and is absent from the public opening at Studio 28 on 28 November. To celebrate this, an exhibition is organized at the cinema from 23 November to 3 December with works by Dalí, Ernst, Miró and Tanguy. Dalí shows *L'Hostie en bague*, *Invisible Sleeping Woman, Horse, Lion, etc.* (no.122), *The Birth of the Day* and *The Widow*. On 3 December members of the Patriotic League and the Anti-Jewish League interrupt the projection, daub the screen with ink and destroy some of the works exhibited. After this scandal a press campaign is organized by *Le Figaro*, *L'Echo de Paris* and other newspapers, demanding that the film be banned. After requesting certain cuts, the censors ban the film completely following a petition from the Italian Embassy. On 10 December the Prefecture bans the film, an action upheld 'a posteriori' in a communiqué from the Board of Censors, which had previously passed the film.

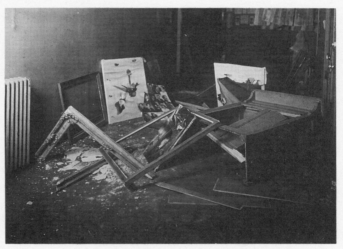

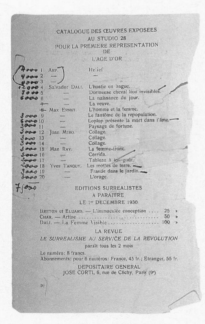

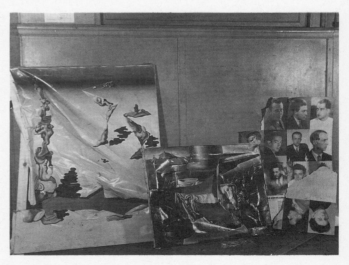

Price list of paintings exhibited in the foyer of the Studio 28 cinema for the opening of *L'Âge d'or* (no.153).

Photographs of vandalism to paintings at Studio 28 during the exhibition to coincide with the opening of *L'Âge d'or* (no.167).

SALVADOR DALI

LA FEMME
VISIBLE

EDITIONS SURRÉALISTES
A PARIS
1930

Title-page of Dalí's *La Femme Visible*,
published in 1930 by Editions Surréalistes,
Paris.

20 November: Editions Surréalistes publish René Crevel's book *Dalí ou l'antiobscurantisme*.

15 December: Editions Surréalistes publish Dalí's book *La Femme Visible*, which collects texts that have appeared in various journals, among them 'The Rotting Donkey', in which he sets out the basis of his paranoiac-critical method. Dalí illustrates it with three engravings and Breton and Eluard write the prologue.

Notes

We are grateful for the suggestions and corrections made by Dawn Ades, Ian Gibson and Antoni Pitxot, who kindly agreed to read this text.

Unless noted otherwise, all manuscripts, letters and documents quoted or reproduced are from originals in the Archive of the Fundació Gala-Salvador Dalí, Figueres or the Fundación Federico García Lorca, Madrid.

1. *Secret Life*, p.1.
2. Ana María Dalí, *Noves imatges de Salvador Dalí*, Barcelona, 1988, p.20.
3. Guillaume Apollinaire, 'Exposition Ramon Pichot', *L'Intransigeant*, 11 Nov. 1910; trans. in *Apollinaire on Art*, ed. Leroy C. Breunig, New York, 1972, p.117.
4. *Diary*; trans. in *A Dalí Journal 1920*, Reynolds Morse (ed.), Cleveland, 1962, p.27.
5. *Diary*.
6. *Letters to Lorca*, p.12: letter 1, second fortnight of June 1925.
7. Ibid., p.24: letter 9, end November 1925.
8. *L'Amic de les Arts* (Sitges) no.9, pp. 10–11.
9. *Letters to Lorca*, p.46: letter 19, 18/20 January 1927.
10. See Félix Fanés, 'The First Image', pp.90–6 of this catalogue.
11. *Letters to Lorca*, p.88: letter 36, early Sept. 1928.
12. The translation incorporates the passages as translated by Ian Gibson in his *Federico García Lorca*, London, 1989, pp.216–7.
13. Jean Vigo, *Vers un cinéma social*, 1930.

Salvador Dalí: the Catalan background
Ian Gibson

Perhaps the first thing to bear in mind about Salvador Dalí is that he was not simply a Spaniard, but a Catalan. On both his father's and his mother's sides being Catalan was a serious matter. It meant among other things that you resented Catalunya's political subservience to far-off Madrid and maintained that there should now be a solid measure of devolution; that you deplored the fact that since the eighteenth century the Catalan language had been officially demoted in favour of Castilian; that culturally you felt as close, or closer, to France than to the rest of Spain; that you believed firmly in the virtues of thrift and hard work; and that, while you had probably never been to Madrid, you were in no doubt that Barcelona was an infinitely more attractive, civilized, modern and (as the 1888 International Exhibition had demonstrated) enterprising city. Salvador Dalí assimilated his parents' fervent Catalanism. It conditioned who he was and what he became.

Born in 1904 in the bustling market town of Figueres, capital of the Upper Empordà region in northern Catalunya, at a stone's throw from the French frontier, Dalí had both city and country blood in his veins. His mother, Felipa Domènech Ferrés (1874–1921), was from Barcelona; his father, Salvador Dalí Cusí (1872–1950), from the isolated fishing village of Cadaqués on the Costa Brava.

The Dalí forbears were agricultural labourers living in the little town of Llers, five kilometres from Figueres, where they can be traced back to 1558.[1] The origin of the surname Dalí, so rare in Spain as to be now almost extinct, has not yet been conclusively established. The painter claimed to descend from the Moors who invaded Spain, and it may turn out that the first Dalís to settle in Llers were *moriscos*, that is Spanish Muslims forcibly converted to Christianity under the new order imposed by Ferdinand and Isabella after the fall of Granada in 1492. Perhaps they came from Aragon. At all events, it seems worth pointing out that the Catalan noun *adalil* (Castlian *adalid*), 'guide' or 'leader', is Arabic, as is the term *dalí*, used in the Ebro region to designate a kind of strong staff wielded by the 'leader', or *daliner*, of the men employed to tow boats from the riverbank. Dalí liked to boast that his Christian name, Salvador, showed that he was destined to be the 'saviour' of Spanish art; had he realized that his unusual surname coincided with the word for 'guide' or 'leader' in Arabic, he would no doubt have informed the world. As it was, he enjoyed pointing out that it corresponded phonetically to the Catalan *delit*, 'delight', 'pleasure'.

Early in the nineteenth century Pere Dalí Ragué, the painter's great-great-grandfather, a blacksmith, moved to Cadaqués (why we cannot say), married a local girl and raised a family. About him and his immediate descendents we know disappointingly little.[2] Around 1881, Galo Dalí Viñas, the painter's grandfather, took himself, his wife and two sons, Salvador and Rafael (ten and eight respectively), to Barcelona, because, according to family tradition, he had grown to hate the *tramuntana*.[3] This fierce north wind, bitterly cold in winter, is the Catalan version of the mistral, blasting down through the passes of the Pyrenees, sweeping the sky clear of clouds, forcing the cypresses of the Empordà plain almost to their knees, smashing flowerpots and coating the cliffs white with salt lashed from the waves. The *tramuntana* can affect the emotions as violently as

it does the sea and countryside. The Empordanese are known for their intransigence (the Dalís were no exception), and it is sometimes claimed that this characteristic derives from their having to push constantly against the wind. Anyone a little dotty in these parts is likely to be labelled *atramuntanat*, 'touched by the *tramuntana*', while depressives can be driven to absolute despair, and even suicide, by a prolonged bout of the furious wind – and the bouts can last for eight or ten days. Perhaps Galo Dalí feared that, if he stayed on, he was in mortal danger.

If so, running away did not save him. In Barcelona, with funds acquired no one has discovered how, Galo put the boys into a good private school and began a career of speculation on the stock exchange. In 1886, at the age of thirty-six, when the market took a sudden turn for the worse, he lost a considerable amount of clients' money and jumped to his death from a balcony after an acute attack of what appears to have been persecution mania.[4]

In his published work Salvador Dalí never once refers to his grandfather's suicide, taboo in the family. We know from the painter's favourite cousin and exact contemporary, Montserrat, however, that eventually he discovered the truth, as she did.[5] That it shocked him there can be little doubt, and one is surely justified in assuming a connection between Dalí's stubborn silence on the subject of Galo, his insistence that he himself was sane ('the only difference between a madman and me is that I am not mad') and his development, fifty years after the family tragedy, of the 'critical-paranoiac method'.

When Galo Dalí died his wife, Teresa Cusí, and the two boys were were taken in by Josep Maria Serraclara Costa, a young lawyer who in 1883 had married Catalina Berta, Teresa's daughter by a previous marriage. Teresa lived with her son-in-law until her death in 1912.

The Serraclaras were passionate Catalanists, but not separatists – they wanted Spain restructured as a federal republic – and Gonçal, the eldest brother of Josep Maria, was elected M.P. for Barcelona in 1869 and forced into exile in France between 1870 and 1882. Josep Maria also had an active political career, became famous as a defence lawyer in political trials and, later, was sometime mayor of Barcelona. Both Galo Dalí's sons imbibed Catalanism from the Serraclaras and were passionate in their defence of the language. Similar in temperament and physique, the Dalís enjoyed arguing about religion and politics and could suddenly flare up violently. They were militant anticlerical atheists, and Salvador would remain so for forty years – until, that is, the excesses of the 1936–9 civil war drove him to reconsider his position, whereupon he became as aggressive a Catholic as previously he had been a free-thinker. Salvador Dalí Cusí argued his case, whatever it happened to be, with missionary zeal, as would his famous son. After taking a law degree from Barcelona University in 1893 he worked for a few years in the Serraclaras' office and then made up his mind to go it alone and become a notary public. Unlike his brother Rafael, who felt no urge to return to the Upper Empordà, Salvador had fond memories of his village and its surroundings. He decided, therefore, to apply for the *notaría* in Figueres when it fell vacant. It did so in 1899, but he failed to win it. It did so again in April 1900 and this time he succeeded.[6]

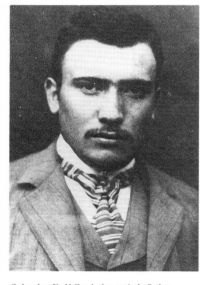

Salvador Dalí Cusí, the artist's father.

Having secured his desired post, Salvador Dalí Cusí was in a position to marry his fiancée, Felipa Domènech Ferrés, the daughter of a Barcelona wholesale haberdashery importer, Anselm Domènech Serra, who had died in 1887, aged only forty-seven, when she was thirteen. Anselm's widow, Maria Anna Ferrés Sadurní, was a quiet, sensitive soul with an artistic temperament inherited from her father, a talented craftsman of, almost certainly, Jewish descent. Several objects done by the latter in tortoiseshell, or embellished with it, became Dalí family heirlooms – boxes, walking stick knobs, fans, an urn, combs for fixing the *mantilla* in Holy Week processions, even a book with tortoiseshell covers.[7]

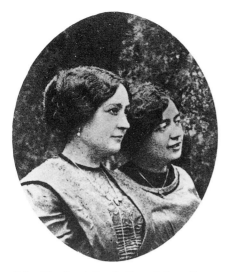

Felipa Domènech Ferrés, the artist's mother, and her sister Catalina.

Felipa Domènech Ferrés, her mother's first child, had been followed by Anselm (1877) and Catalina (1884).

While still a lad, Anselm Domènech Ferrés began to work in Barcelona's best-known bookshop, the Llibreria Verdaguer, founded in 1835, which belonged to his uncle, Alvar Verdaguer Coromina, who had adopted him on the early death of his father. Also a publishing house, the bookshop had played a prominent role in the 'Renaixença', the Catalan literary revival.[8] When Verdaguer died, Anselm took over the business. Today a café, the Llibreria Verdaguer stood directly opposite the Opera House (Liceu) on the Ramblas, Barcelona's famous boulevard, and was a favourite meeting place for writers and artists. Anselm Domènech Ferrés had great personal charm. Deeply involved in the flourishing artistic and literary life of the city, in touch with cultural trends in Europe, he adored music, whether Catalan folksongs or Wagner, and knew everyone in town. He would be a faithful – and useful – friend to his nephew Salvador Dalí, supplying him with books and magazines both Spanish and foreign and encouraging him in his vocation.[9]

Anselm Domènech's two sisters also had their professions. Felipa helped her mother in the workshop, showing considerable skill as a designer of 'artistic objects' – she drew well – while Catalina, twelve years younger, set up as a dressmaker.[10]

Salvador Dalí Cusí had met Felipa Domènech while on holiday in the village of Cabrils, where the Serraclaras owned a charming summer house.[11] Nothing is known of their courtship. They were married in Barcelona on 29 December 1900.[12]

The Dalís' first child was born in Figueres on 12 October 1901 and baptized Salvador Galo Anselmo: Salvador after his father and paternal great-grandfather, Salvador Dalí Cruanyes, Galo after his ill-fated grandfather, and Anselmo in deference to his maternal grandfather, Anselm Domènech, and the latter's son of the same name. We hardly know anything at all about this first Salvador, who died twenty-two months later, on 1 August 1903, victim, according to his death certificate, of an 'infectious gastro-enteritic cold'.[13]

Nine months and ten days later, as if conceived in the urgency of grief, the 'real' Salvador Dalí was born, on 11 May 1904. He was baptized Salvador Felipe Jacinto.[14] The second Salvador was not named after the dead child, as has sometimes been asserted, but after his father and great-grandfather, just as his brother had been before him. (In Catalunya, as in the rest of Spain, the same Christian names were regularly handed down from generation to generation, Dalí's uncle Anselm Domènech being another case in point.) It would have been unheard of, certainly, to burden the new son with the second and third names of his deceased brother, thereby making the identification complete, and of course the Dalís did not do this. Felipe was no doubt chosen as the male form of Felipa, the child's mother, while Jacinto was a gesture in the direction of Rafael Dalí Cusí, Don Salvador's brother, whose full name was Rafael Narciso Jacinto.

In Dalí's extant adolescent diaries there is not a single reference to his dead brother.[15] There are frequent allusions to him in his subsequent writings, however, and they are shot through with misinformation and fantasy. In the *Secret Life* Dalí tells us that his brother was seven when he died and that his demise (from meningitis, he alleges, in blatant disagreement with the death certificate) occurred three years before his own birth, not nine months. He goes on to assert that his brother had 'the unmistakable facial morphology of a genius', showing signs of 'alarming precocity'.[16] This in a child who, as we now know, died when twenty-two months, not seven years, old! Later Dalí claimed that his parents had committed a 'subconscious crime' by giving him the same name as his dead brother and thereby forcing him to live up to an impossible ideal.[17] Most of what Dalí has to say about his brother appears to be pure make-believe, a pseudo-Freudian hypothesis cooked up to supply the curious with an arresting but

Salvador Dalí with his parents. Private collection.

Salvador Dalí (extreme right) does not seem impressed by the attention being lavished on his sister Anna Maria, secure in the arms of her nurse. Felipa Domènech, Salvador's mother, is seated in the centre foreground with her own mother, Maria Anna Ferrés, beside her. Behind the latter is Don Salvador Dalí Cusí. Second from the left, smiling at the camera, is Felipa Domènech's sister Catalina. The other figures have not been identified. Private collection.

Salvador Dalí around his fourth birthday.

spurious justification for the painter's eccentricities and, perhaps also, a smoke-screen to put biographers, whom Dalí despised and probably feared, firmly off the track.

Salvador Dalí was a chronic case of what in England or France would be termed the 'spoilt child' (a concept almost absent in Spain). His parents, perhaps blaming themselves to a certain extent for the death of their first child, were over-protective with the second and seem habitually to have given him his own way, encouraging a pattern that was to persist until his death. From the day he came into the world Salvador Dalí got exactly what he wanted and was even more fussed over from the age of six onwards, when grandmother Maria Anna Ferrés and her daughter Catalina arrived from Barcelona to join the family. The three women, plus the maids, were on hand day and night to cater to Salvador's every whim. Stubborn as a mule in pursuit of his own interests, worshipped, cajoled, cossetted, spruced, petted and polished, Salvador was cock of the Dalí roost – and remained so despite the arrival, in January 1908, of his sister Anna Maria.

Salvador Dalí Cusí stayed closely in contact with the Barcelona side of the family after moving to Figueres, and it soon became customary for the Dalís to spend every Christmas and New Year with the Serraclaras, as well as some weeks each summer in Cabrils.

For Salvador the Christmas reunions meant an exciting train ride, a guaranteed deluge of affection and presents at the other end, the bustle of a great city, marvellous entertainment and the thrill of being taken to Gaudí's Parc Güell, a wonderland where he later wrote he had experienced 'unforgettable anguish' (Gaudí was to be one of Dalí's great heroes).[18] Christmas provided the perfect opportunity, too, for tantrums, and Anna Maria recalled that Salvador used to get so worked up on these visits that he never stopped crying and raging. From her account one cannot but feel desperately sorry for the child's gentle mother, temperamentally quite unprepared, it seems, for coping with his accesses of uncontrollable fury.[19]

Parc Güell, Barcelona, 1916.

The Carrer de Caamaño, Figueres, in 1911. The Dalís' first-floor flat was at the end of the block on the right. A long balcony (not visible) directly overlooked the gardens belonging to the Marquesa de la Torre, which can be seen behind the railings. Soon after the picture was taken the gardens were built on and the Dalís moved house. Both Salvador and his sister Anna Maria remembered them with nostalgia. Photo courtesy of Don Pere Buxeda, Figueres

6. FIGUERAS - 1911 — Calle de Caamaño

In 1910, after two years at the Figueres municipal kindergarten, run by a dedicated and eccentric teacher called Esteban Trayter, Dalí's father enrolled him at the college opened in the town the previous year by the Christian Brothers, recently outlawed in France. At its inception the majority of the school's 120 pupils were French, sent as boarders by their parents when the mother college in Béziers was closed down. Instruction was entirely in French, and it was this that appealed to Don Salvador Dalí, who, hugely ambitious for his son, was determined that he achieve fluency in the neighbouring language. As a result

of the six years he spent with the Christian Brothers Dalí acquired excellent spoken French. Not written, however: the language's unphonetic spelling was beyond him, and even in later life he never mastered it.[20]

Between the ages of six and twelve Salvador Dalí spoke and heard French much more often than Spanish, which he hardly used at all, since at home, as with his friends outside school, conversation was habitually conducted in Catalan. When he left the Christian Brothers in 1916 to begin his six-year State *bachillerato* course at Figueres Instituto, however, the balance would tilt in favour of Spanish – Catalan was proscribed in the Institutos – but by then the French language was deeply rooted in his unconscious. This factor explains the ease and pleasure with which the adolescent Dalí would take to French literature, a dominant influence on his life, and settle down later in Paris.

The Christian Brothers school was important to Dalí in another respect. In 1927 he recalled that his art teacher there used to issue his pupils with simple drawings and require them to block these in carefully with watercolours. His advice was simple. 'To paint well, to paint well in general', he would insist, 'consists in not going over the line'. It was an aesthetic principle that Dalí, in retrospect, found admirable.[21] Whether the same anonymous brother initiated his charges into the use of oil colours has not been established, although it seems unlikely. At all events there is no doubt that by the time Salvador left the Christian Brothers, in the summer of 1916, he had begun to experiment at home in that medium. His earliest known pictures – several tiny watercolours of the Empordà countryside near Figueres – seem to have been done when he was ten or eleven, his first oils a little later.[22] They reveal an acute sensitivity to nature – meadows, sky, animals, mountains, water – which is also reflected in Dalí's adolescent writings.

Salvador installed his first studio in an abandoned laundry-room on the broad flat roof of Carrer Monturiol, 20, where in 1912 his family had moved into a fine new apartment overlooking the Plaça de la Palmera.[23] From there he could enjoy a striking view of the lush Empordà plain, fringed by the coastal range of Sant Pere de Roda and the Bay of Roses. Of this rooftop domain Dalí was absolute lord and master. For company he had the complete collection of Gowan's Art Books (52 volumes) – miniature reproductions of the great masters up to Lawrence which began to be issued in 1905, a year after his birth (no.144). 'The Gowans collection is closely linked to my childhood', Dalí wrote later. 'From a very early age I remember the collection in our home and I used to look at the reproductions with positive delight. I adored Rubens's sensual nudes and the Flemish domestic scenes'.[24] He also hugely enjoyed Ingres, 'falling in love' with the naked girl of *The Fountain*.[25] So well did he get to know his collection of Gowans that later he had difficulty in sorting out his 'real' experiences from those lived vicariously through the reproductions.[26]

At Barcelona University Salvador Dalí Cusí had become close friends with a desultory law student called Josep ('Pepito') Pichot Gironés, whose father was a Barcelona businessman and brother Ramon a talented painter and comrade of Picasso. At the turn of the century Pepito Pichot settled in Figueres and soon afterwards the family acquired a low-lying barren promontory, called Es Sortell, on the south-east rim of the bay of Cadaqués, where they proceeded to build an unpretentious holiday house, soon enlarged. Before long Cadaqués – then extremely inaccesible by land – became a summer mecca for the bohemian friends of the seven Pichot brothers and sisters, all of whom were artistically gifted, not least Pepito, who, despite his lack of formal training, was considered by Dalí 'perhaps the most artistic of them all'.[27] Among the visitors was Picasso, who arrived with Fernande Olivier in the summer of 1910.

At about this time, when Salvador was five or six, his father began to rent a little house in Cadaqués from Pepito's sister, the famous opera singer María Gay, known in the family as Niní.[28] Within hailing distance of the Pichots, it stood

Dalí. *Dutch Interior* (after Manuel Benedito), 1914, oil on canvas, 16.5 × 20.
Private collection.

Es Sortell, the Pichots' house overlooking the bay of Cadaqués.

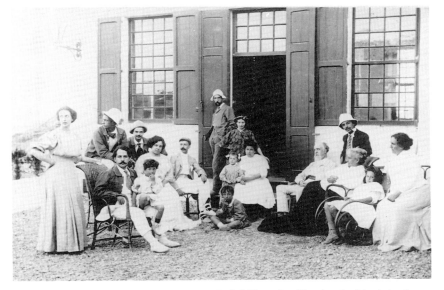

The Pichot clan at Cadaqués: in the group on the left Mercedes, Ricard and a friend stand behind Eduardo Marquina, María with one of her children and Antonio; Ramon stands behind the central group; on the right Luis is behind their parents, Ramon Pichot Mateu and Antonia Gironés. The photograph was taken in 1908 by Pepito.

El Molí de la Torre, María Gay's mansion outside Figueres.

Photographs of the rocks of Cape Creus.

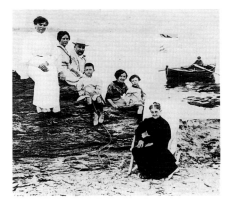

The Dalí family at Cadaqués, c.1910: (left to right) Aunt Maria Teresa, the mother and father of the artist, Salvador, Aunt Catalina, Anna Maria, Grandmother Anna.

at the very edge of Es Llaner beach, a few yards from the sea. Behind were orchards and olive groves, enclosed within dry stone walls and traversed by tiny lanes picking their way up the steep hillside, while on the other side of Es Sortell came a profusion of coves and islands bounded, at Cala Nans, by the lighthouse. This was Salvador Dalí's childhood paradise, which later grew to embrace all of Cadaqués and its immediate surroundings. He loved the village with fanatical intensity, and during the school year in Figueres never ceased to dream of the forthcoming holidays at Es Llaner. Cadaqués, not surprisingly, provided the main inspiration of his early work.[29]

Among the wonders of Cadaqués and its neighbourhood which Salvador began to explore as a child, Cape Creus, lying just to the north, reigned supreme. This massive headland, the most eastern point of the Iberian Peninsula, is, as Dalí reminds us in the *Secret Life*, 'exactly the spot where the mountains of the Pyrenees come down into the sea, in a grandiose geological delirium'.[30] Indented with innumerable creeks (even the smallest with its own evocative name), the cliffs and escarpments of Creus are composed of easily eroded mica-schist of slaty texture. Over the centuries the rains and the *tramuntana*, the latter laden with a corrosive cargo of sand and salt, have sculpted the mica-schist into weird shapes that, as one watches, no sooner assume the form of, say, a phantasmagoric bird or animal than they turn into a wrinkled human profile, a fairy palace or a clump of tropical vegetation. Creus is a vast natural theatre of optical illusions, and from the prolonged contemplation of its metamorphoses was to come Dalí's obsession with the double image, one of the hallmarks of his mature art. His 'mental landscape', he told Louis Pauwels, resembled 'the protean rocks of Cape Creus',[31] while on another occasion he said he felt he was a human incarnation of this primitive landscape.[32] It was at Creus, moreover, that Dalí would have his first sexual encounters with Gala in 1929, alluded to in many of the paintings of the period. For the presence of the cliffs and pitted mica-schist rocks of Creus in the current exhibition, see *The Great Masturbator* (no.112) of 1929 – inspired by a weird shape at the inlet of Cullaró – *Accommodations of Desire* (no.116) of the same year and *The Font* (no.118) of 1930.

The Pichot family's house in Cadaqués was strictly a holiday spot, as was the Dalís'. For the rest of the year Pepito lived with his wife in a rambling property in Figueres that backed onto a walled garden much frequented by the young Salvador, to whom Pichot had taken an almost avuncular liking (see illus. p.18).[33] The latter's sister María, the opera-singer, owned a fine mansion and estate just outside Figueres called El Molí de la Torre ('Tower-Mill'), which Pepito administered on her behalf. Here, in June 1916, the twelve-year-old Dalí spent a few weeks with Pepito and was deeply affected by some of Ramon Pichot's late-impressionist and *pointilliste* paintings (as he was by the blossoming body of Pepito's adopted daughter, Julia, the Dulita of the *Secret Life*).[34] Ramon Pichot, who has never received the critical attention he deserves, was undoubtedly the major influence on Dalí's development as an artist, his model both technically and thematically, as Dalí makes clear in the *Secret Life*. In this respect one could compare, for example, Salvador's *Cala Nans* (c. 1920) with Pichot's painting of the same title, or the scenes from country life done by both.[35]

With the impressionist bit firmly between his teeth ('I am an Impressionist', Salvador told Pepito categorically that summer of 1916, by his own account),[36] there was no stopping him. Dalí's work over the next few years, his diaries and autobiography all attest to Impressionism as the revelation that showed him his way.

In the autumn of 1916 Dalí entered no less than three different schools in Figueres: the official Instituto – to begin his *bachillerato*, two years later than the norm – the Marist Brothers College (for extra tuition) and the Municipal Drawing School.

Drawing by Dalí on a physiology schoolbook. Museo Abelló, Mollet.

Very little is known about Dalí's time with the Marist Brothers (the archives were destroyed during the Civil War), but his progress-sheet at the Instituto has survived (see p.22). Contrary to the image he projected later, Dalí worked hard during his six years there and passed all his annual examinations, often with distinction, finishing the course in the summer of 1922. An anxious student, the thought of failure terrified him, while mathematics, algebra and trigonometry drove him almost to distraction.

The director of the Municipal Drawing School, Juan Núñez Fernández, was a graduate of the Special School of Painting, Sculpture and Engraving, the teaching division of the San Fernando Royal Academy of Fine Arts in Madrid, which Dalí would later attend, and was talented at charcoal drawing and engraving. An inspiring teacher, Núñez immediately recognized and encouraged his pupil's ability. At the end of the academic year Dalí was awarded a certificate for his performance, and Don Salvador was so delighted that he improvised an exhibition of his son's work in the family apartment.[37] If Ramon Pichot was the first great influence on Dalí's art, it was Núñez who helped him to develop his technique, both at the Municipal Drawing School and the Instituto, where he also taught. The delightful drawings, often extremely witty, with which Dalí lavishly extra-illustrated his *bachillerato* textbooks, and which include some fetching naked ladies, no doubt owe a debt to Núñez, while suggesting at the same time how infinitely boring he must have found several of his classes at the Instituto.[38]

Salvador exhibited officially for the first time in January 1919, sharing the occasion with two other, and older, painters, Josep Bonaterra i Gras and Josep Montoriol Puig. The art critic of a local paper, *Empordà Federal*, was emphatic in his praise of the fourteen-year-old artist, predicting that he would be 'a great painter'.[39] It seems to have been the first time that Dalí, later media-mad, was extolled in print. It is not known exactly which works were on display. One of them – a charcoal drawing of Cadaqués – was probably that acquired later by Reynolds Morse and today in the Salvador Dalí Museum in Florida. It showed, undoubtedly, remarkable flair – and the strong influence of Núñez.

The critical success of the exhibition must have pleased Salvador greatly. But even more so, perhaps, the gesture by an affluent friend of his father's, Joaquim Cusí Fortunet, who bought two of the paintings, probably the first the young artist had sold.[40] It is worth underlining that, from the moment he began to paint, Dalí was a prophet in his own country, hailed as a prodigy by the local press, fully supported by his parents, encouraged by the Pichots and even patronized by a rich family friend. Endowed with a huge natural ability and an impressive capacity for hard work, it seemed clear that he was destined for success. All he had to do was to keep on painting.

By the end of 1918 Dalí was writing as compulsively as he was painting, perhaps influenced by one of his teachers at the Instituto, Gabriel Alomar, with whom he studied Spanish language during his first year there and who, it appears, was the first to perceive his literary ability.[41] Alomar, a writer less known than he should be today, earned himself a footnote in the textbooks by inventing, in 1905, the term 'Futurism' (shortly afterwards appropriated by Marinetti), and could boast of having been a close friend of the great Nicaraguan poet Rubén Darío (1867–1916), who revolutionized Spanish verse at the turn of the century and was deeply admired by Dalí and his schoolfriends. A passionate federalist republican, Alomar was popular in Figueres, a federalist hotbed. The town returned him to the Madrid parliament in June 1919, and his books and lectures were frequently discussed in the pages of *Empordà Federal*. Dalí could hardly fail to have been impressed.

Salvador's first published work appeared in a small magazine, *Studium* (see illus. p.20), which he and four friends at the Instituto launched in January 1919 and which ran for six issues. As well as helping with the magazine's illustration,

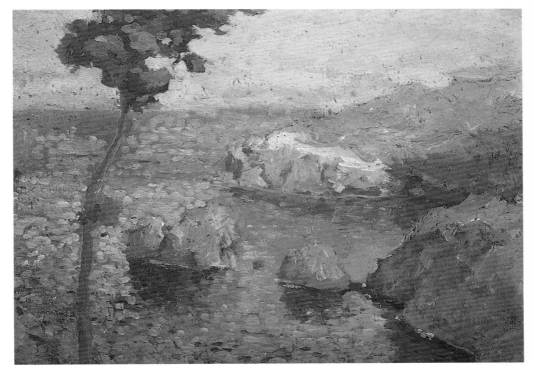

Ramon Pichot. *Cala Nans*, oil on cardboard, 36 × 48. Private collection.

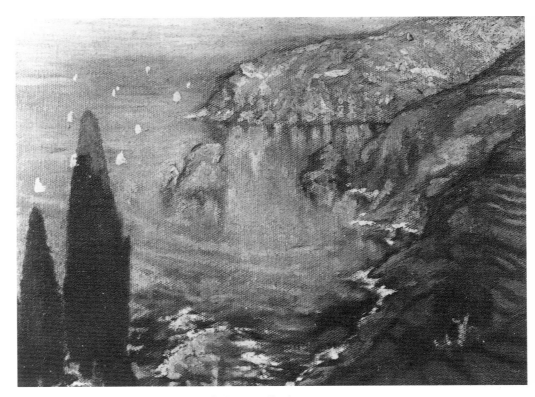

Dalí. *Cala Nans*, c.1920, oil on canvas, 40 × 50. Private collection.

Drawings for the artist's sister, 1916, ink on paper, 32.5 x 24.5. Fundació Gala-Salvador Dalí, Figueres: Dalí bequest 1989 (no.2).

Drawings for the artist's sister, 1917, ink on paper, 32.5 x 24.5. Fundació Gala-Salvador Dalí, Figueres: Dalí bequest 1989 (no.2).

Old Man at Twilight, 1918, oil on canvas, 50 × 30. Private collection, Barcelona (no.3).

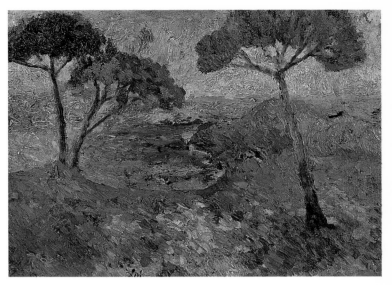

The Sailing Boat 'El Son', c.1919, oil on cardboard, 24 × 19.
Fundació Gala-Salvador Dalí, Figueres: Dalí bequest 1989 (no.4).

The Three Pines, c.1919, oil on canvas, 28 × 38.
Private collection, Cadaqués (no.5).

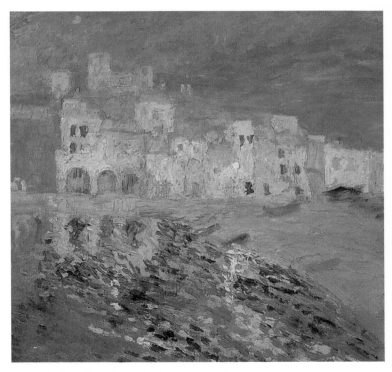

Garden with pots, c.1919, watercolour on paper, 21.6 × 27.
Fundació Gala-Salvador Dalí, Figueres: Dalí bequest 1989 (no.6).

Cadaqués (Port Alguer), c.1920, oil on canvas, 36 × 38.
Fundació Gala-Salvador Dalí, Figueres: Dalí bequest 1989 (no.7).

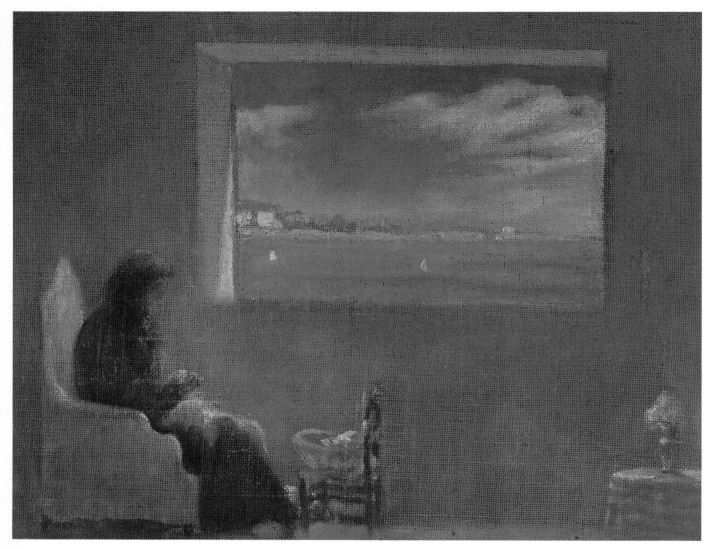

Portrait of Grandmother Anna Sewing, c.1920, oil on canvas, 48 × 62. Private collection, Figueres (no.9).

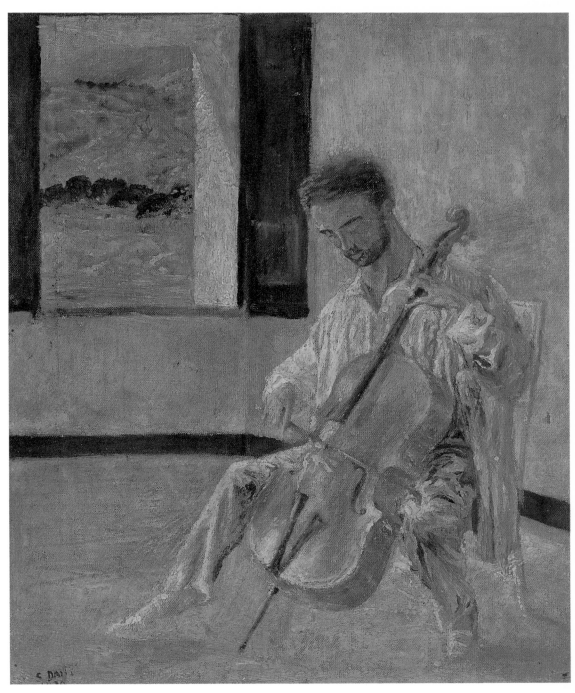

Portrait of the Cellist Ricard Pichot, 1920, oil on canvas, 62 × 49. Private collection, Cadaqués (no.8).

Study for a painting, *My Family*, 1920, pencil and ink on paper, 22 × 16.5.
Private collection, Cadaqués (no.11).

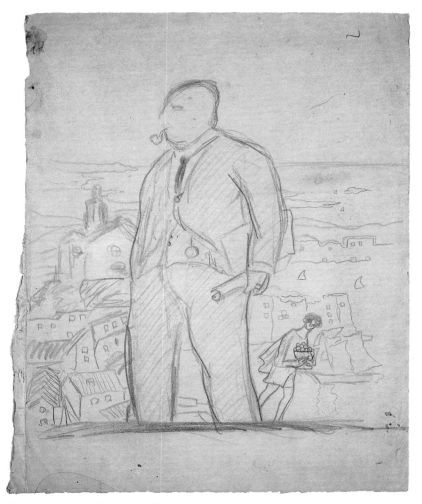

Study for *Portrait of My Father*, 1920, pencil on paper, 32.5 × 26.
Fundació Gala-Salvador Dalí, Figueres: Dalí bequest 1989 (no.12).

Two studies for *Portrait of My Father*, 1920, pencil on paper, 23 × 32.8.
Fundació Gala-Salvador Dalí, Figueres: Dalí bequest 1989 (no.13).

Studies for a self-portrait and *Portrait of My Father*, 1920, pencil on paper, 12.5 × 30.5.
Fundació Gala-Salvador Dalí, Figueres: Dalí bequest 1989 (no.14).

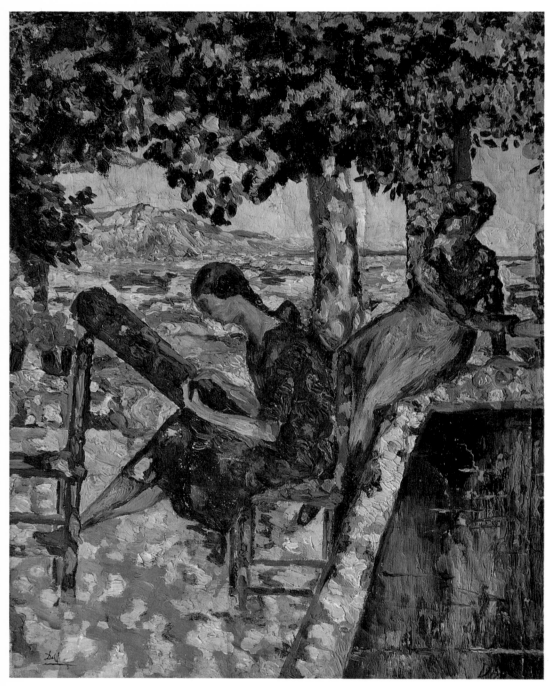

Girls in a Garden, c.1920, oil on canvas, 53 × 41. François Petit, Paris (no.10).

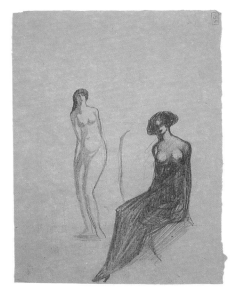

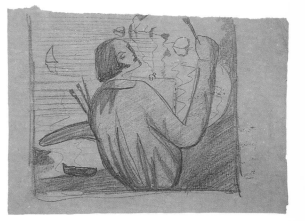

Two female figures, 1920, pencil
on paper, 22.1 × 16.6.
Fundació Gala-Salvador Dalí,
Figueres: Dalí bequest 1989
(no.15 verso).

Study for a self-portrait, 1920,
pencil on paper, 16.6 × 22.1.
Fundació Gala-Salvador Dalí,
Figueres: Dalí bequest 1989
(no.15).

Two scenes with gypsies, 1921,
pencil on paper, 22.3 × 33.2.
Fundació Gala-Salvador Dalí,
Figueres: Dalí bequest 1989
(no.20).

Figure drawings, 1921, pencil on
paper, 22.3 × 33.2.
Fundació Gala-Salvador Dalí,
Figueres: Dalí bequest 1989
(no.20 verso).

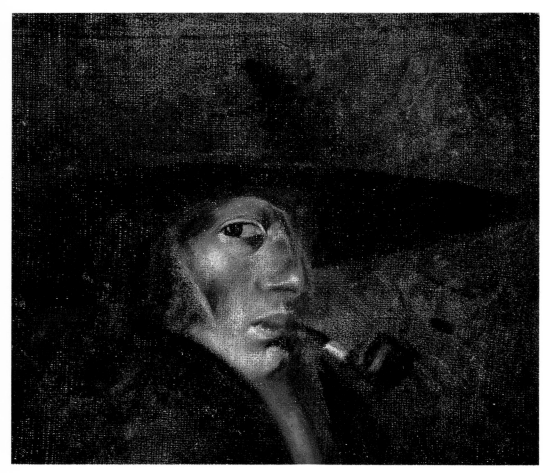

Self-Portrait, 1921, oil on canvas, 37 × 42. The Salvador Dalí Museum, St. Petersburg, Florida (no.21).

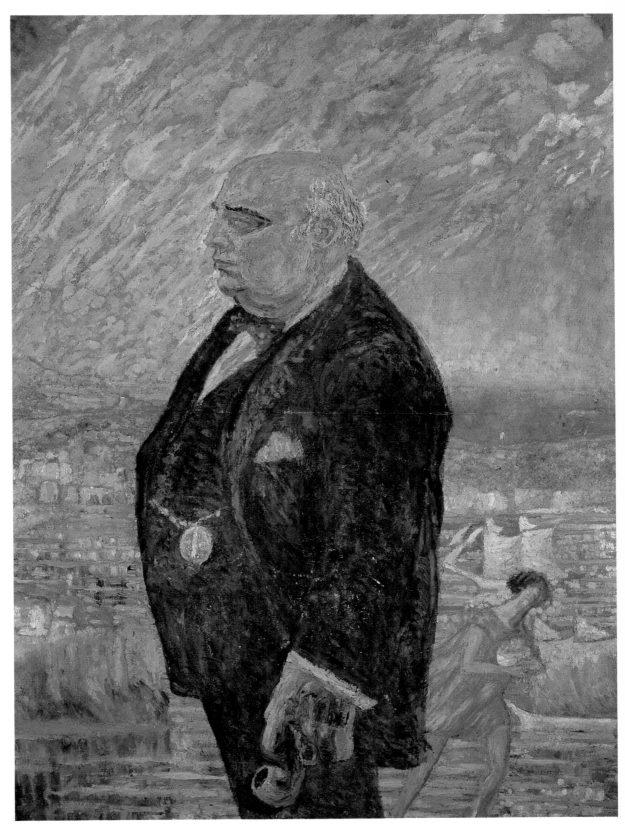

Portrait of My Father, 1920, oil on canvas, 91 × 66. Fundació Gala-Salvador Dalí, Figueres: Dalí bequest 1989 (no.16).

Sardana of the Witches, 1921, watercolour on paper, 41.9 × 59.7. The Salvador Dalí Museum, St. Petersburg, Florida (no.19).

Salome, c.1921, ink on paper, 14.4 × 24. Fundació Gala-Salvador Dalí, Figueres: Dalí bequest 1989 (no.23).

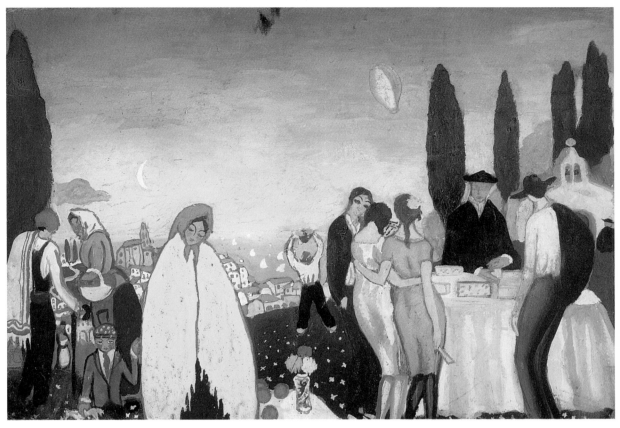

Fiesta at the Hermitage of Saint Sebastian, Cadaqués, 1921, gouache on card, 52 × 75. Fundació Gala-Salvador Dalí, Figueres (no.22).

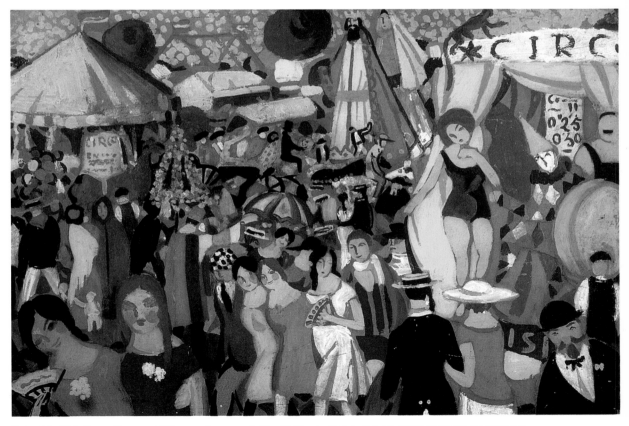

Fair of the Holy Cross, Figueres, 1921, gouache on card, 52 × 75. Fundació Gala-Salvador Dalí, Figueres (no.22 verso).

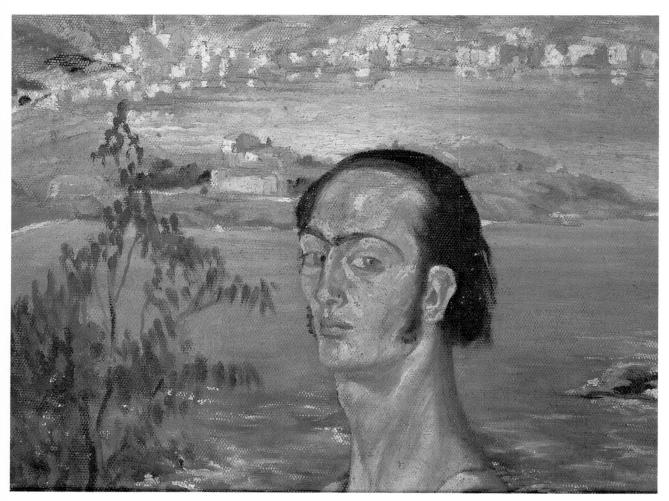

Self-Portrait with 'Raphaelesque' Neck, 1921–2, oil on canvas, 41.5 × 53. Fundació Gala-Salvador Dalí, Figueres: Dalí bequest 1989 (no.24).

The Madrid years
Rafael Santos Torroella

It cannot be doubted that there is a 'Madrid period' in the life and work of Salvador Dalí, nor that it demands close attention, marking as it does one of the most vital stages in his brilliant and spectacular career as an artist. Indeed, one may trace in this period the essential elements of the genetic code of Dalí's painting and aesthetics.

The period runs from the end of 1922 to the middle of 1926. That is, from Dalí's admission to the Residencia de Estudiantes and Special School of the Academia de Bellas Artes in Madrid until his definitive expulsion from the latter (he had already been suspended temporarily in 1923). The works that he painted at this time remain, with very few exceptions, among the least known and are largely unfamiliar to the general public. They still seem to labour under the weight of André Breton's judgement, according to which 'when Dalí insinuated himself into the surrealist movement in 1929' – there was clearly a pejorative tinge to the 's'introduit', in the sense of something surreptitious – 'his previous work as a painter had suggested nothing strictly personal.'[1] It had been quickly forgotten that, when Picasso visited Dalí's first one-man exhibition at the Galeries Dalmau in Barcelona in 1925, he returned to Paris brim-full of praise for the young painter from Catalunya. Miró had been similarly impressed two years later after seeing Dalí's second one-man exhibition at the same gallery; indeed he was so enthusiastic that he travelled to Figueres to try and persuade Dalí's father to allow him to go to Paris, where, he assured him, he would be certain of great success.

The Family
Dalí's family is the prime element in the 'genetic code' of his life and work which I have already mentioned. Always linked by close ties to his home environment, when his Madrid period began in 1922 Dalí had already painted most of the eighty or so pictures which it is calculated make up his 'early work'. He was therefore no longer a novice, although only eighteen years old. He had tried his hand at everything: landscapes, still lifes, picturesque genre paintings of Cadaqués fisherman or Figueres gypsies, and any number of drawings ... Among the portraits, one of his father is exceptional (no.16): he is seen in profile, standing majestically on a slope dominating the bay of Cadaqués, beneath a sky luridly streaked with red, incandescent clouds. It is an ambitious and passionate painting which tells us a great deal about what this imposing figure meant to his son. Another canvas was planned, this time of the whole family, calmer and more serene in mood if of no less distinction and importance. To know what the new portrait might have been like all we have to guide us is an interesting preparatory study in a private collection in Cadaqués (no.11), reproduced and exhibited here for the first time. It is proof of the extent to which, by 1920, the painter was prepared to embark on more ambitious projects.

The triangular composition of the group of four figures in this drawing should be noted. The painter's mother, Doña Felipa Domènech, slender and of strikingly noble bearing, stands in the centre, her hand resting on the shoulder of her daughter Anna Maria (who can only have been about twelve at the time). On their left sits Don Salvador, as if in the prow of a boat, the supporter and

Portrait of My Father, 1920, oil on canvas, 91 × 66. Fundació Gala-Salvador Dalí, Figueres: Dalí bequest 1989 (no.16).

Dalí has expressed what an imposing figure his progenitor represented for him by placing him, as if on a huge pedestal, atop an eminence rising above their home at Es Llaner. From here he dominates the bay of Cadaqués and seems to take possession of his surroundings, while his daughter Anna Maria, then, as she told the author, about twelve years old, comes running with a basket of fruit. This, quite apart from the technical considerations, leads one to prefer a date of 1920 to that of 1922, usually assigned to this picture.

no doubt ironically, succeeded in injecting it with the precise plastic reality which, in truth, he must have considered his great victory. He did not reap the success he had expected, though; even his friends on the magazine *L'Amic de les Arts* had mixed feelings about the painting, which was soon forgotten. Purchased by a family acquaintance, it has never again been shown in public, while even the occasional photographs of it that have been published in recent years are faded reproductions of the few that appeared in Catalan periodicals at the time.[9]

What gives added interest to this work, clarified today by our new understanding of Lorca and Dalí's relations – basically deriving from Dalí's statements and from his correspondence with the poet and other friends – is that, as I have said, it constitutes the first iconographic key to the emblematic and symbolic representation of their friendship.

In my view it is in fact, as I have indicated, a portrayal of a youthful St Sebastian, perhaps the self-portrait of a person who felt (the letters Dalí wrote to Lorca at the time are quite explicit in this respect) that he had, as it were, successfully withstood the arrows of passion of which he intimates he was the target. In his left hand he clutches a staff or sceptre in the manner of Polykleitos' *Doryphoros*, but it is actually the same staff or branch that, in other depictions of St Sebastian by Dalí, is transformed into a magnified vein in which the degrees of temperature provoked by amorous passion are mathematically registered. An effort must be made to keep this passion always well under control as the first step towards being able to mould it in accordance with an aesthetic and precautionary morality designed to avoid contamination – a morality always present in Dalí during the period of his intimate relationship with Lorca. This vein also prefigures or anticipates the metaphorical gadgets described in Dalí's famous 1927 essay on St Sebastian (see pp.214–5), in which he stated that everything could serve as a 'pretext for an aesthetics of objectivity' and that the indi-

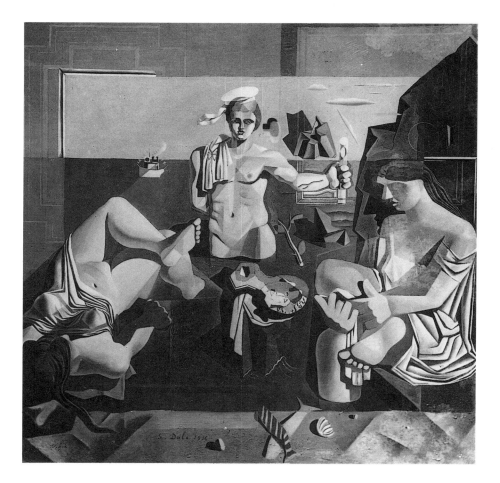

Composition with Three Figures (Neocubist Academy), 1926, oil on canvas, 200 × 200. Private collection, Barcelona.

For the present writer, this, the largest of Dalí's early works, is an emblematic and metaphorical representation of the Christian martyr St Sebastian, with whose drama Dalí felt himself darkly and pathetically identified. The painting marks, moreover, the division between the 'Anna Maria period' and the 'Lorca period' that followed it and was to lead Dalí inexorably towards Surrealism.

cations on the gadgets were 'a starting point for a whole series of intellectual delectations, and a new range of precisions for hitherto unknown normalities.'

The sailor's cap, tilted slightly to one side – possibly inspired by Cocteau's illustrations for his *Le Grand Ecart* – serves as a martyr's halo. Dalí had already used this image with a certain witty affectation in a sketch he gave to Lorca, as had the latter in a drawing also reflecting their shared appropriation of the saint. In the centre of the painting, below the body of the youth and the branch at his side, which symbolizes the tree to which he was tied (also suggested by the way in which the figure's right arm is bent back), one can see in the plaster head a playful allusion to those of the idolatrous cult destroyed by the martyred saint, with the aid of the priest Polycarpus, in the presence of the Roman prefect Cromatius. Although similar heads can be appreciated in Picasso's large still lifes of this period, this one has specific qualities that allowed the young painter to associate it with the new theme which we know had begun to obsess him. Looking at it closely, we see that it is a double head – perhaps the first of the many 'double images' that Dalí was later to incorporate into his 'paranoiac-critical' method. His own face, more triangular in shape, is in the centre, and to its right, merging with it and casting its shadow below in almost lugubrious black, is the squarer and less well-defined head of Lorca. We will find this double image of the two friends reappearing in countless variations in other paintings and drawings of Dalí's 'Lorca period'. Returning to the rest of the composition, note, in the foreground of the painting (which represents a stretch of the beach at Es Llaner), the phallic double image made of a tie (the same striped tie worn by the protagonist of *Un Chien andalou*) and the fish, a double image that would be repeated in various forms that year.

Above all, however, we should remark the perfect compositional triangle that, in the manner of the Italian Renaissance, Dalí used here in order to place two Picassian female figures in its lower angles, its apex being occupied by the sailor/St Sebastian. The almost naked figure seen in bold foreshortening on the left is Venus, or perhaps Lust. Her colossal head is balanced by the dense shadow that envelops her; and, no matter how paradoxical it may appear, by the equally colossal shadow cast by the face of the female personage on the right. The latter, a figure more redolent of modesty, represents Virtue, or Reflection, somewhat hieratic but very human in her self-absorption. Meanwhile, St Sebastian rises above them as if announcing, in the name of Dalí and with premonitory certainty, what André Breton would write three years later in the catalogue of the Catalan's first Paris exhibition: that Dalí is 'like a man hesitating' (although the future will show that he did not hesitate) 'between talent and genius, between, as would have been said in an earlier age, vice and virtue.'

Notes

1. A.Breton, *Surrealism and Painting*, trans. Simon Watson Taylor, New York, 1972, p.73.
2. *XXᵉ Siècle* monograph on Dalí, Paris, 1980, p.114.
3. A singular example is the painting *Figure on the Rocks* (no.77), which contains Picassian distortions and shadows in the manner of de Chirico. One of these shadows is of Anna Maria's profile, cast in black onto her right arm. This detail merits close attention, as it often goes unnoticed.
4. Dawn Ades, *Dalí*, London, 1982, pp.21–2.
5. *Secret Life*, p.205.
6. Rafael Alberti, *La arboleda perdida*, 2nd ed., 1982, p.160.
7. *Documents* (Paris) no.5, 1930, p.268; republished in facsimile by Ed. Jean-Michel Place, Paris, 1991.
8. *Valori Plastici* (Rome), 1921, vol.III no.4, p.87.
9. Fortunately I have been able to include among the illustrations to this essay a copy of the original photograph that was made for Dalí in 1926 by the well-known Barcelona photographer Francesc Serra (1877–1967), whose archives went to the Museu d'Art de Catalunya on his death.

The first image – Dalí and his critics: 1919 to 1929
Fèlix Fanés

Although Barcelona was a city outside the artistic mainstream, during the 1920s there was a well organized and established art market there, with a body of collectors, dealers and critics who generated news and comment both in specialist art magazines and the daily papers. As a result, it is possible to form a clear picture of the way Salvador Dalí's early work was received by the art world and also, to some extent, by society as a whole. He was singled out by the press at an early stage, and an image rapidly began to take shape, arousing first admiration, then shock and finally panic.

The first image we have of Dalí is that of a very talented landscape painter: 'He is an artist who will be much discussed,'[1] wrote a Figueres daily paper. 'Prodigious instinct,'[2] exclaimed one of the most influential Barcelona newspapers. He was described by a third in a more lyrical vein as a painter who 'finds his subject-matter in the natural beauty of the landscape surrounding Cadaqués.'[3] His work was indeed extremely lyrical, and as a young artist Dalí had a highly romantic temperament, which gave him a very special sense of his relationship to nature: 'To be lost in the ecstasies of the mysteries of light, of colour and of life itself. To envelop my soul in nature. Going ever further, ever into the beyond. More light, more blue. More sun.'[4] His surprisingly strong political attitudes came from the same source: 'The world revolution is becoming closer and more palpable every day. I desire it and look forward to it. I am ready to embrace it with open arms and with this cry on my lips: "Long live the Soviet republic". If at first tyranny is necessary in order to attain true democracy and a real socialist republic, then I say: "Long live tyranny!".'[5]

His character, romantic and sentimental, enthusiastic and revolutionary, was reflected in his paintings of the period; they were in a raw mixture of styles but did not lack charm. There were signs of full-blown Impressionism, flourishes of Fauvism and several incursions into Catalan popular painting. The influence of the Catalan painter Xavier Nogués was clearly felt in such works as *Déjeuner sur l'herbe* of 1921 and was frequently cited in early articles on Dalí: 'He has clearly been deeply impressed by our great master Nogués.'[6]

Joan Subias, a childhood friend of the painter's and, consequently, aware of the sources that inspired him in his early years, described his development as 'impressionist', 'pointillist' and 'fauvist'. However, Subias points out that Dalí was influenced by 'decorative Cubism' at a very early stage, notably in the 'tumultuous compositions' executed in 'tempera, with primary colours', in which 'circuses, festivals and country picnics' all feature. The most interesting development was what Subias referred to as Dalí's 'geometric schema'.[7] This geometric tendency, adopted by the painter when he was still only a high-school student in Figueres, is of special significance because it became his life-line after he arrived in Madrid and found that the very same melting romanticism and 'painting of sensation' which he practised was the favoured style at the Academy. It soon became intolerable to see his own reflection in that mirror, and he decided to undergo a process of purification, 'containing forms' and 'learning good manners', as he later confessed to his friend the critic Sebastià Gasch.[8] It was a process that was crucial for Dalí's development, since through his discovery of Cubism he was able to rid his palette of any trace of the tradi-

Déjeuner sur l'herbe, c.1921, charcoal on paper, 26 × 39.5. Private collection. This may be the work exhibited in January 1922.

tion of humanism or of lyricism and to focus on 'constructive concerns'.[9] This accounts for his rigorously structured paintings, in which technique, skill and discipline are the prime considerations.

There were several sources for this new means of expression. Although the influence of the Uruguayan painter, Rafael Barradas, then living in Madrid, is often mentioned and should not be underestimated,[10] it is especially important to remember that Dalí had access to a vast number of foreign art books, magazines and periodicals. Among these, the most significant was surely the futurist catalogue of 1914 (no.127), which had apparently been given to him by Pepito Pichot after a trip to Paris,[11] and the magazines *Valori Plastici* and *L'Esprit Nouveau*, which Dalí probably obtained from his Uncle Anselm Domènech's bookshop on the Rambles in Barcelona.[12] During these years Dalí gave the impression of someone whose concerns were wholly theoretical, and it was not unusual for him to be regarded as an artist 'more gifted with cool intelligence than with a pure, pictorial sensibility'; 'with so much theorizing,' he had almost 'killed off any intellectual honesty'. His painting was, in the opinion of many, 'somewhat breathless' and 'terribly arid', and he was gaining a reputation as a cold, dogmatic painter who lacked inspiration.[13]

However, the most remarkable thing at this period about Dalí, whom his friend the poet José Moreno Villa referred to as the 'geometer', is the dualism inherent in his work. 'Dalí plays two apparently opposing cards,' wrote Rafael Benet in *La Veu de Catalunya*, 'the traditional card' alongside 'the card of audacity'.[14] Although Dalí's eclecticism was greeted with some reservation by conservative critics, who felt that he was 'trying to please everyone' and 'was incapable of resisting the applause of fools',[15] his alternation of styles was generally well received. The avant garde in Barcelona had always been eclectic, and Dalí's dualism did not at first cause much surprise. This may have been due primarily to the very special character of Catalunya, where *Noucentisme* had been adopted as official artistic policy, through which contacts with modern trends were maintained and Cubism was welcomed, if somewhat tentatively. At the same time, the international artistic community, including Picasso himself, had embraced the 'rappel à l'ordre' proposed in Paris.[16] In Madrid, however, where Dalí was living, although the general level of awareness of avant-garde movements was quite low ('in Madrid, unlike Barcelona,' he wrote to his friend Joan Xirau, 'modern avant-garde painting has not only had no impact, it isn't even known about'[17]), ignorance of 'new art' was not as widespread in certain literary circles as it was in the broader cultural field. Writers who were aware of the latest trends nevertheless took a somewhat ambivalent stance, looking for 'a dialogue with tradition'. Moreno Villa was one of the few who welcomed artistic innovation, and, as well as being a poet, he was an avant-garde painter and one of Dalí's friends at the Residencia de Estudiantes.[18]

In any case, the paintings in quite different styles that Dalí showed in the exhibition of 'Artistas Ibéricos' in Madrid in 1925 and in his first one-man show at Galeries Dalmau in Barcelona the following year – whether because this stylistic diversity conformed with the prevailing artistic environment or because his methods were considered to reflect institutional cultural programmes – did not arouse special comment; nor did the works that he showed the following year in the exhibition of 'Modern Catalan Art' in Madrid and in the first Autumn Salon in Barcelona. In all these exhibitions Dalí played the 'traditional card', as in *Seated Girl Seen from the Back* (no.66), alongside the 'card of audacity', in, for example, *Departure (Homage to Fox Newsreel)*. This policy was noted but was never overtly criticized; it was even seen as further proof of the young painter's talent. But by the autumn of 1926 the unanimity with which Dalí was greeted as a hugely talented painter – rather cold and cerebral, but technically very assured – was already beginning to crack. When he showed in the 'Exhibition of Catalan Pictorial Modernism' at Galeries Dalmau and had his second one-man exhibition at the same gallery at the end of the year, there was a

Lorca, Dalí and the sculptor Alberto Sánchez at the Exposición de Artistas Ibéricos in Madrid, 1925.

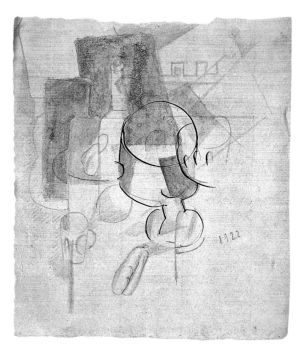

Still life with glass, 1922, pencil, ink and wash on paper, 15.5 × 13.
Fundació Gala-Salvador Dalí, Figueres: Dalí bequest 1989 (no.36).

Nativity, 1923, pencil on paper, 34.9 × 25.6.
Private collection, Cadaqués (no.37).

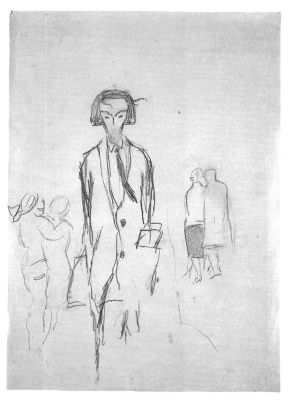

Study for a self-portrait, 1923, pencil on paper, 22 × 15.4.
Fundació Gala-Salvador Dalí, Figueres: Dalí bequest 1989 (no.38).

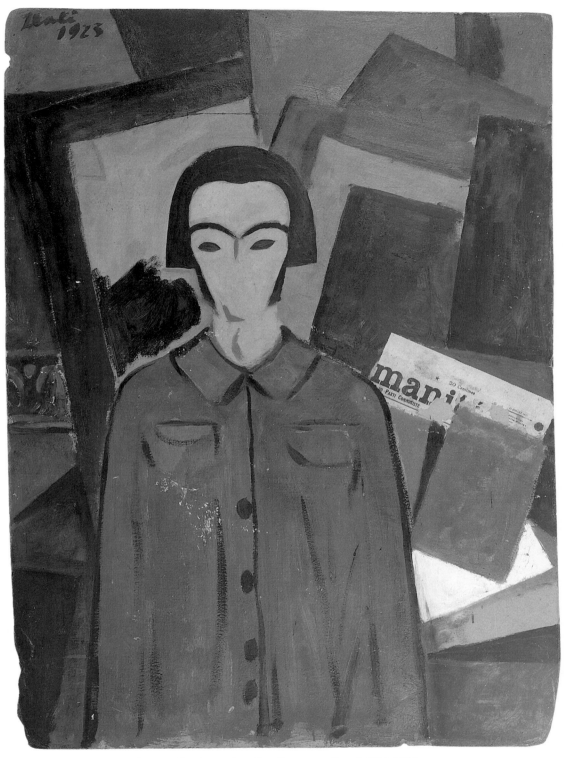

Self-Portrait with 'L'Humanité', 1923, oil and gouache with collage on cardboard, 104.9 × 75.4.
Fundació Gala-Salvador Dalí, Figueres (no.39).

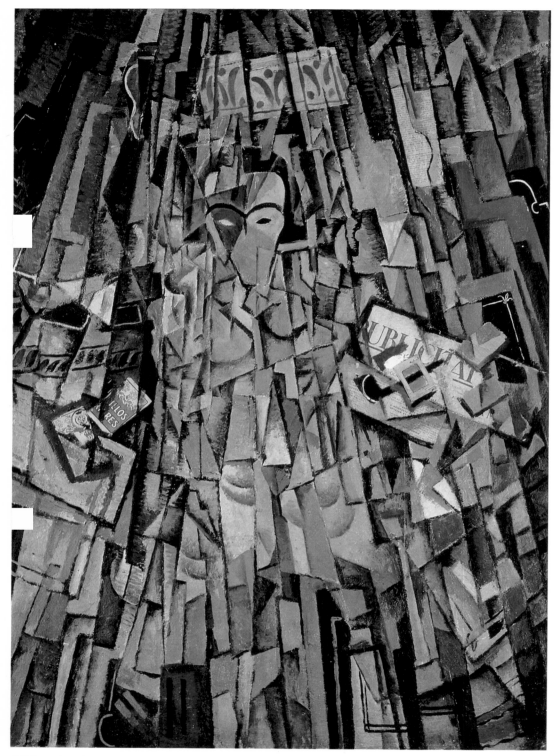

Self-Portrait with 'La Publicitat', 1923, gouache on cardboard, 105 × 75.
Museo Nacional Centro de Arte Reina Sofía, Madrid (no.40).

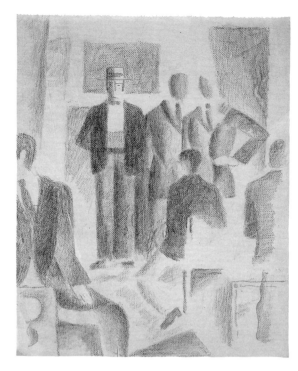

Group of men, 1923–4, crayon on paper, 19.7 × 15.2.
Fundació Gala-Salvador Dalí, Figueres: Dalí bequest 1989 (no.43).

Study: Pastoral scenes, 1923–4, pencil on paper, 23.5 × 62.5.
Fundació Gala-Salvador Dalí, Figueres: Dalí bequest 1989 (no.44).

Reclining woman, 1923–4, pencil and wash on paper, 16.3 × 25.
Fundació Gala-Salvador Dalí, Figueres: Dalí bequest 1989 (no.45).

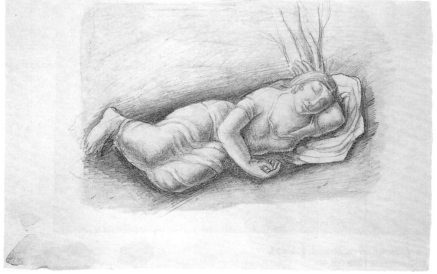

Portrait of Manuel de Falla, 1924–5, pencil on paper, 31.2 × 23.3.
The Salvador Dalí Museum, St. Petersburg, Florida (no.52).

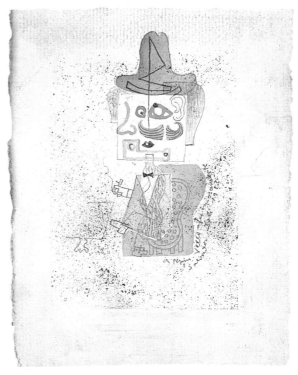

Pepín Bello, 1923, pencil, watercolour and wash on paper,
12.6 × 9.3.
Fundació Gala-Salvador Dalí, Figueres: Dalí bequest 1989
(no.41).

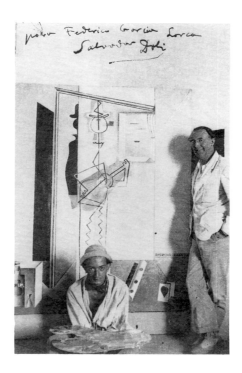

Dalí with his uncle Anselm Domènech in
1925 in front of *Large Harlequin and Small
Bottle of Rum*; photograph dedicated to
Lorca.
Fundación Federico García Lorca, Madrid
(no.161).

Facing page:
Large Harlequin and Small Bottle of Rum,
1925, oil on canvas, 198 × 149.
Museo Nacional Centro de Arte Reina Sofía,
Madrid (no.53).

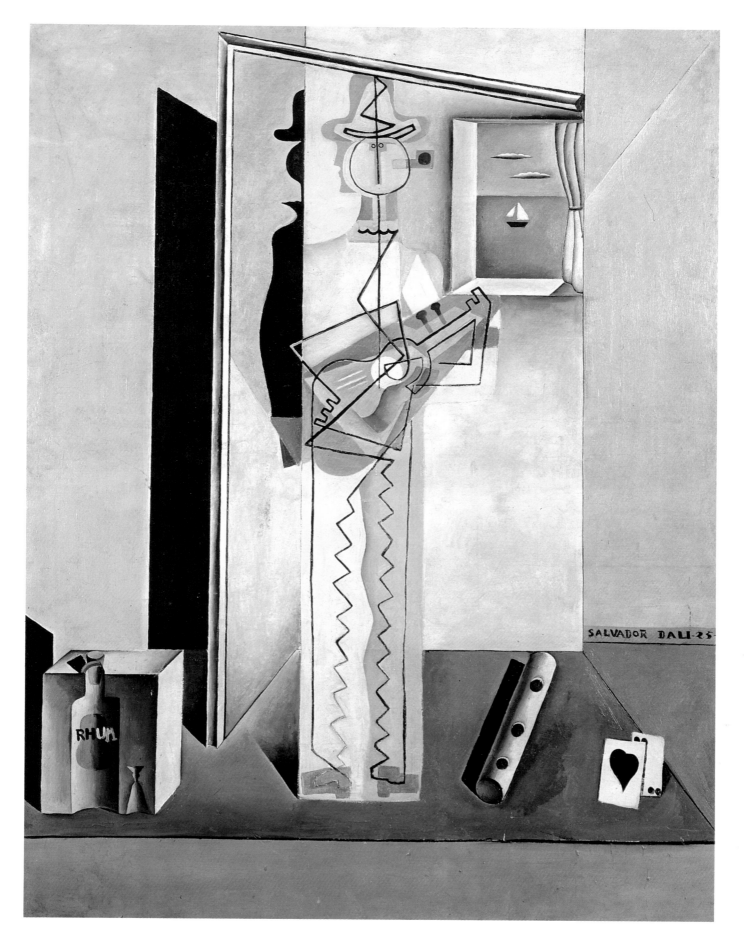

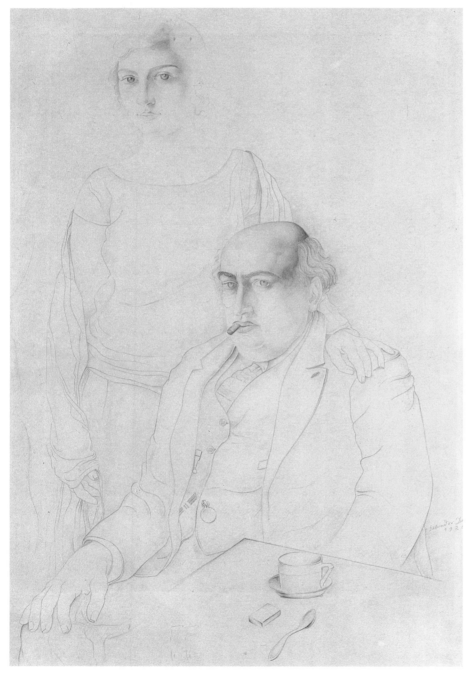

The artist's father and sister, 1925, pencil on paper, 49 × 33.
Museu Nacional d'Art de Catalunya (Gabinet de Dibuixes i Gravats), Barcelona (no.64).

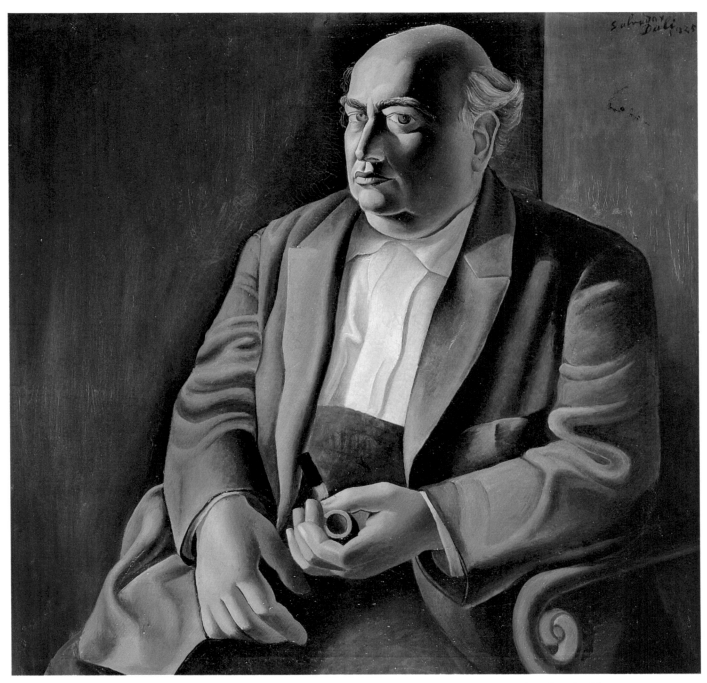

Portrait of My Father, 1925, oil on canvas, 104.5 × 104.5. Museu Nacional d'Art de Catalunya (Museu d'Art Modern), Barcelona (no.65).

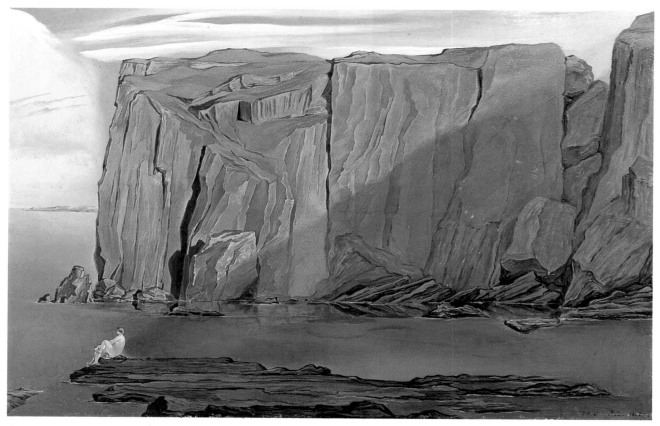

Cliffs (Woman on the Rocks), 1926, oil on panel, 27 × 41. Roberto Gallotti, Milan (no.76).

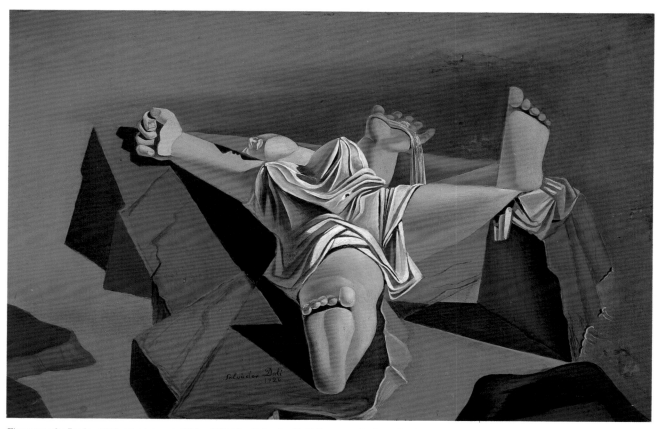

Figure on the Rocks, 1926, oil on panel, 27.5 × 40.5. The Salvador Dalí Museum, St. Petersburg, Florida (no.77).

Morphologies of desire
Dawn Ades

The cluster of paintings that marked Dalí's entry into the surrealist movement in 1929 are usually seen as the starting-point – and, in some ways, apogee – of his career. Startling conjunctions of ideas and images drawn from Surrealism, psycho-analysis and natural history, they immediately placed him at the centre of the Paris movement. However, both in their aspect – that hyper-real fixing of the imaginary – and in their themes, their roots lie in Dalí's work of the preceding decade. But their relationship to his previous work is quite complex – there are continuities, but also transformations and even reversals of the earlier material. The transformations and reversals owe much to Dalí's growing familiarity with Freud and with the works of French psychiatrists, and to some extensive self-analysis. The paintings seem, overwhelmingly, to be concerned with sex: not just sexual desire, but fears, phobias and obsessions and problems of sexual identity. Readings of these pictures have been dominated by their evident rootedness in psycho-analysis – whether they are taken as deliberate constructs by Dalí, utilizing his familiarity with that science, or as 'pathological documents' bearing witness to his actual neuroses or obsessions. But the tendency to scan the pictures for symbols and to read these off like a chart of symptoms obscures other kinds of ideas and associations, which stand out in relief when linked to his earlier work.

One set of ideas was to lead to his life-long fascination with morphology: 'Glory be to Goethe for having invented this word of incalculable moment, a word that would have appealed to Leonardo!'[1] Morphology is the term used to describe the structures, homologies and metamorphoses of form in animals and plants, or in language. Although as the study of shapes it is of obvious interest to artists, for Dalí morphology was possessed of a range of significant ideas. Categories of form, such as hard and soft structures, came to magnetize crucial qualities, even of a moral and psychological character. And, as the study of hidden forces that govern the structures and transformations of bodies, Dalí made morphology into a materialist analogue to the notion of the hidden forces of the unconscious mind. His vigorous description of the dynamic operation of matter awakens echoes of the powers of repression in the individual psyche:

> Form is always the product of an inquisitorial process of matter – the specific reaction of matter when subjected to the terrible coercion of space choking it on all sides, pressing and squeezing it out, producing the swellings that burst from its life to the exact limits of the rigorous contours of its own originality of reaction.[2]

Through the 1920s he developed his ideas about hard and soft, form and formlessness, the conscious and the unconscious, and eventually about paranoia. To consider the 1929 paintings in the context of his deliberate stylistic contradictions, his equivocal relations with Surrealism and modernism, with machinism and *L'Esprit Nouveau*, and of his initial deployment of surrealist ideas vis-à-vis photography and film, is to get a sense of the nature of the convulsions that produced them.

'Mineral Cadaqués'
If Federico García Lorca can be seen as the modern poet of Granada (a Granada,

though, as Dalí said, without trams or railways), it looked for a time as if Dalí was to become the modern artist of Catalunya. Cadaqués, and especially the strange geology of the landscape round Port Lligat were to remain important to him, though not in the direction his early work had pointed.

As early as 1923, the critic Eugenio Montes, in the Madrid newspaper *La Tribuna*, regretted that a recent poster display celebrating the lands of Castile and Portugal had not also included a poster by Dalí to give a taste of the 'Mediterranean spirit'. This suggests that Dalí was regarded as the latest young recruit to Catalan *Noucentisme*. Although his work does have elements of this Mediterranean classicist movement, the early paintings most strongly marked by a 'Catalanist' sensibility are the bright, poster-like watercolours and gouaches of popular and picturesque subjects. The paintings of gypsies, market scenes and fairs show the influence of paintings of similar subjects by Ramon Pichot, but also his own direct involvement with local life and popular culture that his sister notes in her memoirs.[3] In 1921 he made posters for the Fires i Festes de la Santa Creu, which aroused some controversy because of their bold, flat modern colours; he also, with his friend Subias, decorated a float for the Procession of the Three Kings in Figueres so magnificent that it attracted the attention of the local press.

In January 1922 he showed in Barcelona for the first time, in a mixed exhibition of work by the Catalan Students' Association with paintings that included *Smiling Venus*, *Fiesta at the Hermitage* (no.22), and *Olive Trees*. One critic noted his 'formidable artistic personality',[4] but not the remarkable fact that this manifested itself already in such diverse styles. For, as was to be almost invariably the case over the coming years, Dalí exhibited, simultaneously, paintings in markedly different manners. On the one hand, there was the direct but slightly caricatural picturesque style, often with simple black outlines and clean, flat colours; on the other, evidence of an awareness of Impressionism and Post-Impressionism, also gained largely through the work of Ramon Pichot, who moved regularly between Paris and Cadaqués.

Smiling Venus is a curious amalgamation of the two: a seaside idyll with a raven-haired Venus reclining before a divisionist view of the bay at Cadaqués. How far this painting suggests a sardonic attitude to the revival of the Mediterranean Venus in *noucentista* classicism is an open question. But an inclination towards satire is notable in several works of this period, especially those dealing with popular or Catalanist subject matter. In this, Dalí was still very much within a Catalan tradition. This could best be explained with reference to the Catalan graphic artist Xavier Nogués, to whose work Dalí's frontispiece for a special number of *El Día Gráfica* of 1921, devoted to 'the divine restorer of the *sardana*', Pep Ventura, was compared. Nogués's album of drawings *La Catalunya Pintoresca* (1919) 'contains grotesque figures ... who make up satirical scenes which, without imitating them, were done in the spirit of traditional popular Catalan prints'.[5] A work that fits this model is Dalí's *Sardana of the Witches* (no.19), a watercolour of 1921 closely related to his title-page illustration for Carles Fages de Climent's *Les Bruixes de Llers* (1924). The poem that gives the book its title celebrates, in the same satirical-picturesque spirit, the legend that on a Friday night, if the *tramuntana* wind has blown all week, wizards and witches come out to dance the sardana:

> Wizards and witches crazily ranged
> dance the sardana in open spaces.
> Their ill-omened manes of hair fly in the wind
> sweeping across the clouds.

The revival of the sardana, a 'miracle of Nationalism' endebted to Pep Ventura, was part of the cultural renaissance sponsored by the Catalan government and enthusiastically supported by Dalí's father, a Catalan federalist of the left.

The satirical spirit Dalí absorbed from within this tradition was later to be turned against it. By 1928 rejection of the Catalan or indeed of any picturesque

Design for the cover of *Biografia d'en Pep Ventura*, 1921, watercolour on paper, 13.5 × 19.
Collection Mr and Mrs Reynolds Morse, on loan to the Salvador Dalí Museum, St. Petersburg, Florida.

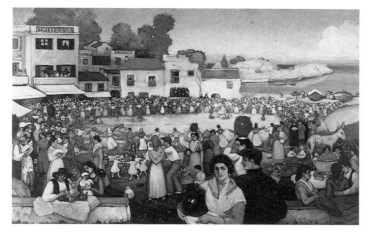

Ramon Pichot. *The Sardana*, oil on canvas, 125 × 91. Private collection.

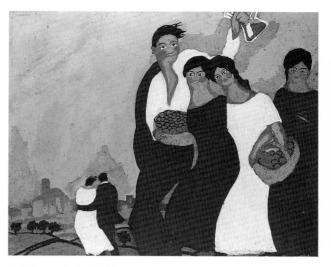

Dalí. Poster design for *Fires i Festes de la Santa Creu*, 1921, gouache on cardboard, 42 × 65.
The Salvador Dalí Museum, St. Petersburg, Florida.

Smiling Venus, c.1921, oil on cardboard, 50 × 51.5. Fundació Gala-Salvador Dalí, Figueres.

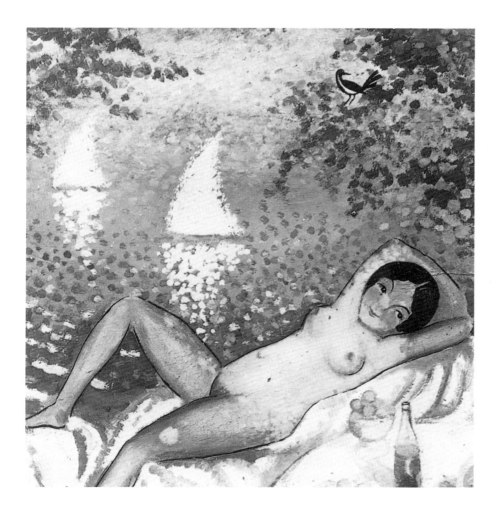

Dalí doing the Charleston; photograph stuck on a page of Dalí's letter to Lorca of 18/20 January 1927 (see p.30).
Fundación Federico García Lorca, Madrid.

was a prominent element in his 'anti-artistic' campaign. A much-quoted lecture by Dalí of that year called for the abolition of the sardana, and the demolition of the Gothic Quarter of Barcelona. When he and Anna Maria took lessons in and had themselves photographed doing the Charleston, it was a quite deliberate rejection of the national Catalan dance in the name of the modern age.

Fiesta at the Hermitage, picturesque as it is, also shows another side of Dalí's political interests as a young man, as recorded in his diary for 1920. A subtle sense of social division is revealed in the separation of the gypsy with headscarf in the centre from the group of townspeople to the right, which includes Dalí himself talking to two young girls seen from the rear, a motif that appears frequently through the early twenties. As in several drawings of the period, such as *My Family* (no.11), Dalí portrays himself as a bohemian young artist; the similarity between the caricatural, triangular face with almond eyes and the later *Self-Portrait with L'Humanité* (no.39) is striking. It is noteworthy that, although one of Dalí's preferred subjects is, undoubtedly, himself, he rarely exhibited self-portraits unless, as we shall see, they were in a more or less disguised form.

The third work in the 1922 exhibition was a landscape of olive trees, regarded by at least one critic (*Alt Empordà*), as the best in the show. Views of Cadaqués, its harbour, olive groves, stone-bordered lanes, bays and wild rocky headlands, as well as of the Empordà plain with its cypresses and wide vistas, were to remain favoured subjects through many radical stylistic transformations. Dalí was increasingly identified with Cadaqués, where his family had a holiday house and where he always painted in the summer. One admirer predicted that he would be 'the poet-painter of our sea'. But Cadaqués also had its connections with international modernism: Picasso at the height of his cubist period, and Derain in his later 'classical' cubist mode had both worked at Cadaqués, an association noted by critics who commented on the shifts in Dalí's landscapes between the stippled post-impressionist manner, a silvery naturalism and a sombre, harder, green-brown cubist style clearly indebted to Derain.

Cadaqués, Cape Creus and the rocky coastal landscape continue to figure in many paintings in the twenties, from the detailed realism of *Cliffs* (no.77), where the human body is overwhelmed by the mass of rock, to 'academic cubist' pictures like *Composition with Three Figures (Neocubist Academy)* (see p.88), where the cubistic bodies and the sharp rocks are equally hard-edged.

Cadaqués became for Dalí the geographical epitome of a morphological category: the hard and crystalline in form. He wrote to Lorca in January 1928, after a visit there, that the village was 'more mineral than ever, the olives grow straight from the smooth shale, like machines, objectivity closed its teeth with force ...'[6] Mineral hardness is linked to the notion of objectivity, which Dalí connected with rigour, order and measure in an increasingly elaborate but finally equivocal schema.

Purism, Measure and Mathematical Lyricism
From the mid-1920s, Dalí consistently and provocatively exhibited paintings in two apparently contradictory styles. It was this cool switching of manners, rather than the extreme vanguardism of his Cubism, which contributed to his controversial reputation.

Although there were inevitably critics who disliked Cubism and Futurism, and whose nostalgia for a comfortable academic naturalism, or in Catalonia for the classicism of *Noucentisme*, guaranteed an unfavourable reception for the various brands of modern art, Dalí was by no means the only artist working in this manner. Barcelona's familiarity with the latest French art, from Cubism to Picabia's Dada and neo-Dada abstractions, is well known, and Madrid was more familiar with Cubism than Dalí suggests in his autobiography (though perhaps not in the Special School where he was studying, whose professors, he noted in 'New limits of painting', were still locked into teaching the primacy of the retinal whether with respect to academic or to impressionist painting). Barradas's